OBATA'S YOSEMITE

Mount Lyell stands majestically,
13,650 feet high, clad in brilliant snow
and towering over the high peaks of the
Sierra—Tioga Peak, Mount Dana,
Ragged Peak, Johnson Peak, Unicorn
Peak, and Mount San Joaquin, which
surround her.
The spotlessly clear blue sky that
sweeps high up over the mountains
changes in a moment to a furious black
color. Clouds call clouds. Pealing
thunder shrieks and roars across the
black heavens. Man stands awestruck
in the face of the great change of
wondrous nature.

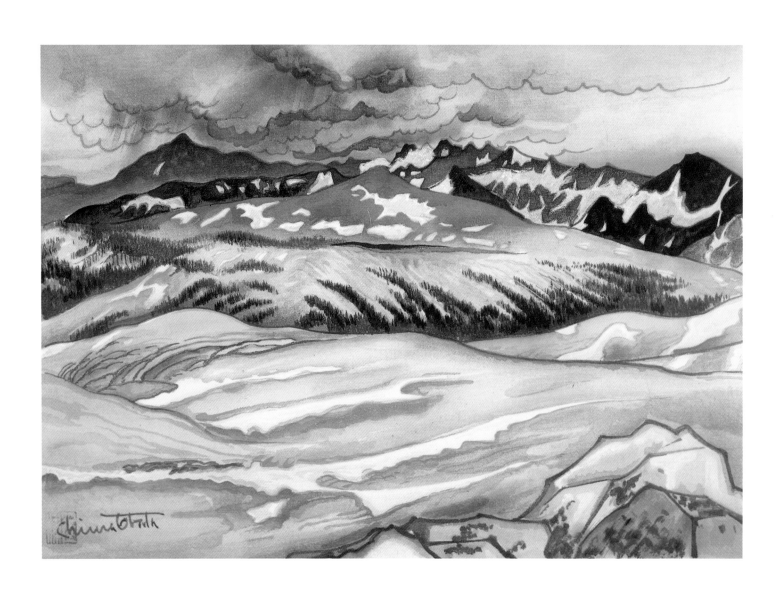

OBATA'S YOSEMITE

The Art and Letters of Chiura Obata

from His Trip to the High Sierra in 1927

with essays by Janice T. Driesbach and Susan Landauer

YOSEMITE ASSOCIATION

YOSEMITE NATIONAL PARK

CALIFORNIA

Yosemite Association
P.O. Box 545
Yosemite National Park, CA 95389

The Yosemite Association is a non-
profit, membership organization
dedicated to the support of Yosemite
National Park. Our publishing
program is designed to provide an
educational service and to increase the
public's understanding of Yosemite's
special qualities and needs. To learn
more about our activities and other
publications, or for information about
membership, please write to the above
address, or call (209) 379-2646.

Printed in Japan.

Unless otherwise noted, the works of
art by Chiura Obata reproduced in
this book are from the collection of
the Obata family; photographed by
Brian Grogan.

Cover:
Evening Moon (detail), 1930.
Color woodblock print, 15¾ x 11 in.

Frontispiece:
*Great Nature, Storm on Mount Lyell
from Johnson Peak*, 1930.
Color woodblock print, 11 x 15¾ in.

The color woodblock prints by Chiura
Obata reproduced in this book are
accompanied by the prose captions
Obata himself wrote circa 1930.

*Library of Congress
Cataloging-in-Publication Data*
Obata, Chiura.
Obata's Yosemite : the art and letters
of Chiura Obata from his trip to the
High Sierra in 1927 / with essays
by Janice T. Driesbach and
Susan Landauer.
Includes bibliographical references.
ISBN 0-939666-66-9 (cloth).
ISBN 0-939666-67-7 (paper).
1. Obata, Chiura. 2. Yosemite Valley
(Calif.) in art. 3. Obata, Chiura—
Correspondence. 4. Artists—California
—Correspondence. 5. Obata, Chiura—
Journeys—California—Yosemite
Valley. 6. Yosemite Valley (Calif.)—
Description and travel. I. Driesbach,
Janice Tolhurst. II. Landauer, Susan.
III. Title.
N6537.O22A4 1993
760'.092—dc20
[B] 93-8320
 CIP

To the memory of
Haruko Obata

Contents

Acknowledgments

It has been a delight to have an opportunity to learn more about Chiura Obata and the color woodblock prints he produced in Japan between 1928 and 1930. As my research into this project progressed, it became evident that the artist, about whom relatively little has been published, and his *World Landscape Series* of prints offered fascinating subjects for exploration.

My efforts to discover more about these works were assisted by many individuals who were able to offer insights about Obata, contemporaneous art in Japan and California, Japanese woodblock-printmaking techniques, and Yosemite, among other subjects. Their generosity in sharing information contributed substantially to my understanding of the artist and the context in which he was introduced to and interpreted Yosemite.

Obata's granddaughter, Kimi Kodani Hill, was of enormous assistance throughout this project, making available to me on many occasions the prints and related works in the family collection, scrapbooks Obata kept, transcriptions of oral interviews with the artist and his wife, and translations of letters and a diary related to my areas of research. She also regularly consulted with her mother, Yuri Kodani, who answered without fail my many questions about Obata and his activities. Their commitment to helping with my scholarship is greatly appreciated.

Also of great assistance was Hidekatsu Takada of Takada Fine Arts in San Francisco, who served as the Kyoto liaison for Crown Point Press when that press published color woodblock prints made after models in watercolor by contemporary artists. Mr. Takada drew on his knowledge of practices in Japan in his comments on the progressive proofs for Obata's *Lake Basin in the High Sierra*, which he generously shared with me. Dr. Helen Merritt, whose outstanding books provide landmark information on Japanese printmaking in the early twentieth century, was most helpful in responding to my questions.

In addition, many other individuals shared their time with me or undertook research on my behalf, for which I am profoundly grateful. They include Virginia Adams; Karin Breuer, Associate Curator, Achenbach Foundation for Graphic Arts, The Fine Arts Museums of San Francisco;

Dr. Katherine Crum, Director, Mills College Art Gallery; Dr. Patricia Graham, Assistant Curator of Asian Art, The Saint Louis Art Museum; Jeff Gunderson, Librarian, San Francisco Art Institute; Michael Harrison; Nan and Roy Farrington Jones; Gene Kloss; Gyo Obata; William Roberts, Archivist, University of California at Berkeley; Tomoe Takahashi; as well as Barbara Beroza, Registrar; Linda Eade, Archivist; Michael Floyd, Photographer; and David Forgang, Curator, Yosemite National Park. I would also like to thank the Co-Trustees and staff of the Crocker Art Museum, whose encouragement and support were instrumental in this project.

Kimi Kodani Hill has asked that I also acknowledge the contributions of Naoko Haruta, Mayumi Yoshida, and Teiko Sano, who helped with translation, and the assistance of Heiichi Isawa, who supported much of the research on Obata family history.

Finally, the Yosemite work of Chiura Obata first came to my attention in conversation with the designer Desne Border, and I thank her and the Yosemite Association president, Steven P. Medley, for their commitment in pursuing a book and related exhibition presenting the unique vision that is *Obata's Yosemite*.

JANICE T. DRIESBACH

I am most grateful to Kimi Kodani Hill for her tireless energy and enthusiasm at every stage of this project. As the designated Obata family historian, Kimi's meticulous organization of the notebooks, clippings, and correspondence relating to her grandfather's art and life eased the task of research considerably. Laela Weisbaum of the Archives of American Art, Smithsonian Institution, West Coast Regional Center, and Jeff Gunderson of the San Francisco Art Institute deserve special mention for expediting the location of important documents. And for reading the manuscript and making useful comments, I would like to thank Fronia Simpson, Karl Kasten, Barbara Klein, and my husband, Carl.

SUSAN LANDAUER

How Old Is the Moon? 2 July 1927.
Sumi on postcard, 5 ½ x 3 ¼ in.

Gyo-chan—How old is the moon?
It shines with a beautiful face.

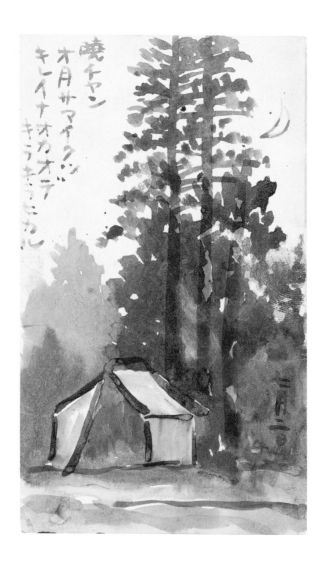

Obata's Yosemite: An Introduction

Born in Japan, Chiura Obata (1885–1975) immigrated to California in 1903.[1] By the 1930s, Obata was influential as an artist and teacher in the San Francisco Bay Area. Among Obata's most important subjects was Yosemite, where he painted many times following his first trip there in 1927. That initial visit, which lasted six weeks, had a profound impact on the artist. Not only did he produce a significant body of work during that time, but the watercolors that Obata made in Yosemite in 1927 served as models for the greater part of an innovative portfolio of prints that he produced in Japan between 1928 and 1930. Through these prints and the related drawings, paintings, and texts, *Obata's Yosemite* addresses the artist's development and places his contributions in the context of both Californian (and American) art and color woodblock printmaking of this time.

Not only did Obata have a strong personal response to the remarkable landscape he encountered, but he also used his journey as an opportunity and a challenge to produce a body of work that would prove his stature as an artist, both to himself and his friends in America and to his family in Japan. Obata met this challenge. The watercolors, sumi, and pencil drawings from the Yosemite trip constituted the majority of the artist's first one-person exhibition, which was held in San Francisco the following spring. On Obata's return to Japan in the fall of 1928, he undertook the production of a portfolio of prints, primarily Yosemite subjects, that would consume some eighteen months and considerable resources. These color woodblock prints were strongly influenced by traditional Japanese practices, but they also incorporated significant technical innovations in an effort to replicate both the watercolors and the artist's experience in the Sierra. In their variety of styles and moods, these images likewise captured the artist's complex response to his subject, which was filtered through his training in Japan and his years in California.

Obata's *World Landscape Series* portfolio comprises thirty-five color woodblock prints. All but one show California scenes, and twenty-seven of them are views of Yosemite and the High Sierra country. The exception is a portrait of the opera singer Madame Talia Savanieva that, like most of the

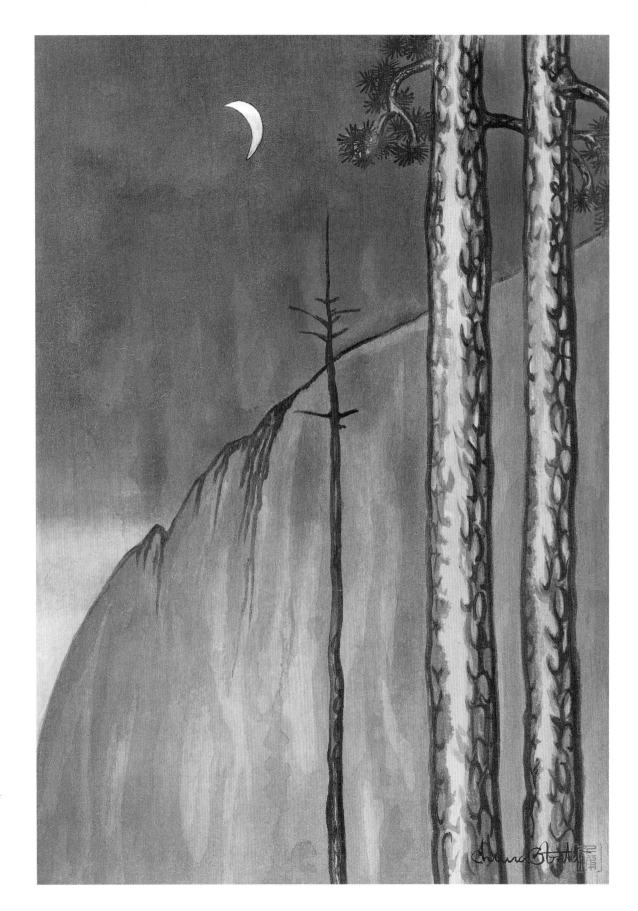

Evening Moon, 1930.
Color woodblock print, 15¾ x 11 in.

From Eagle Peak Trail the massive
stroke of the rocky mountains can be
seen cutting boldly across the heavens
—a prelude of melody before the
evening moon.

subjects, was among the paintings featured in the spring exhibition. While views with such titles as *Spring Rain, Berkeley, California*; *Foggy Morning, Van Ness Avenue*; and *Setting Sun in the Sacramento Valley* appear among the sheets, the dominant theme is established by such works as *Before Thunderstorm, Tuolumne Meadows*; *Sundown at Tioga, Tioga Peak*; *Clouds, Upper Lyell Trail, along Lyell Fork*; and *Evening Moon*. *page 110*
pages 133, 109
page 15

In concept and execution, the *World Landscape Series* was an ambitious and unusual project. That the prints were well received on Obata's return to California is demonstrated by their substantial exhibition record and significant press coverage. However, the prints were accorded scant attention in literature of the period. Whereas the accomplishments of American artists who made prints in Japan during the early twentieth century, such as Helen Hyde and Bertha Lum, and major figures in the Japanese *shin-hanga* print movement, such as Hiroshi Yoshida and Hasui Kawase, have been the subject of study, Obata appears to have been overlooked. It is possible that this is due in part to his perception by others as a Japanese artist working in America and as an American in Japan.

Fortunately, the prints Obata commissioned in Japan have been kept intact in portfolios owned by his family and the Achenbach Foundation for Graphic Arts, The Fine Arts Museums of San Francisco. In addition, the watercolors, other paintings and drawings that Obata produced in Yosemite at the time, progressive proofs made to show how selected prints evolved through successive states, and the artist's correspondence and diary, much of which is quoted in this book, are retained by his descendants. Rarely is such complete documentation of a series of art works available. This wealth of material allows a deeper understanding of the motivations, objectives, and expectations that influenced and guided Obata during this period.

The artist's approach to the work inspired by his first Yosemite visit was grounded in his early education in turn-of-the-century Japan and the artistic community of the San Francisco Bay Area in the 1920s. These experiences allowed him to freshly address a subject that had a long history in California art. During the 1860s and 1870s Yosemite had served as the subject of epic paintings by landscapists who were excited by the awesome scenery they encountered. Grandiose compositions featuring notable landmarks by artists such as Albert Bierstadt, Thomas Hill, and William Keith found a ready market *pages 26, 27* among California entrepreneurs who had realized fortunes from mining and the construction of the transcontinental railroad. The patronage for these monumental compositions collapsed, however, when San Francisco's economy

foundered and a new taste for European painting emerged at the end of the 1870s.

Although Christian Jorgensen operated a successful studio in Yosemite in the beginning years of this century, few leading artists looked to the area for subject matter after his departure in 1919. An exception, however, was William Zorach, who produced fascinating abstracted watercolors during a visit in 1920. The artist most closely associated with Yosemite during this time was Gunnar Widforss, a native of Sweden who was close friends with the director of the National Park Service, Stephen Mather. Mather encouraged Widforss to paint at Yosemite and the Grand Canyon, where the artist spent much of his time. Widforss's Yosemite watercolors from the 1920s, most of which feature motifs from the valley, were prominently exhibited at the Ahwahnee Hotel and purchased by visitors to the park. Many of these compositions describe geographic or architectural features and are painted in a manner that would lend them to reproduction as woodblock prints. Obata would most likely have seen examples by Widforss, although in his own watercolors he concentrated on representing high country motifs and atmospheric conditions.

Other artists visited Yosemite, among them Otis Oldfield and Yung Gee, but they apparently found the landscape unsuited to their formal concerns and produced little work on their visits. Even the impressionist Theodore Wores, who was called a "famous artist" at the time of his visit in 1929, painted only a few views of Yosemite during or following his initial trip. Other oil paintings of Yosemite are regularly described in press accounts during the 1920s but were by artists such as Maurice del Mue and Florence Alston Swift, whose work was infrequently reproduced and is largely unfamiliar to us today. And Ansel Adams, who was to create a modern visual vocabulary for Yosemite through his photography, was just beginning his work in the park, undertaking primarily commercial projects for the concessioner.

Thus Chiura Obata stands out as an artist who adopted Yosemite as a significant subject at a time when the park was receiving increasing public attention but paradoxically decreasing artistic interest. His visit coincided with the opening of the Ahwahnee Hotel on 16 July 1927 as well as with the inauguration of the High Sierra Camps, events that responded to and encouraged Yosemite's higher profile as a tourist resort. Obata is therefore distinguished as an artist who found this California landscape a compelling environment to experience, observe, record, and reflect on, not only in 1927, but again and again throughout his life. His freedom to immerse himself in the Sierra during that initial summer inspired a remarkable record of Yosemite as well as an innovative print portfolio.

Obata
of the
Thousand
Bays

Chiura Obata has a place all his own in the history of California art.
Arriving in San Francisco at the turn of the century with the first wave of
Japanese immigrants, he was instrumental in bringing Japanese brush-and-ink
techniques to the West Coast. While on the faculty at the University of
California at Berkeley, Obata's extraordinary facility with the brush dazzled
a generation of watercolorists and helped promote the idea—central to the
California Watercolor School—that water-based painting could equal oil
painting in freshness of execution. Obata's espousal of the Zen tradition, with
its emphasis on subjective content, led him to imbue his landscapes with an
intense, often calligraphic, expressiveness. Many of his best paintings, however,
contain a quiet lyricism. This is especially true of his Yosemite watercolors and
woodblock prints, which combine a delicate poetry with an unerring eye for the
tranquil beauty of the High Sierra.

EARLY LIFE AND WORK

Obata was born on 18 November 1885 and was raised in the ancient city of
Sendai on the island of Honshu, the largest of the Japanese archipelago.[1] As a
small child he was adopted by his older brother, Rokuichi Obata, an artist of
some renown specializing in Western-style rendering.[2] Obata's artistic talents
were apparent at an early age: by the time he was seven he was studying
classical sumi (ink) painting in the rigorous, exacting manner still prescribed at
the end of the Meiji period (1868–1912). Of his seven-year apprenticeship, the
artist recalled that for nearly two years he was forced to paint lines and circles
without resting his elbows.[3] Only after he had demonstrated perfect control
over the brush was he allowed to prop his elbows and paint freely. Even in this
strict setting, however, Obata showed a headstrong individualism. Rather than
taking his first master's name as was customary in Japan, Obata adopted
"Chiura," meaning "thousand bays," a reference to the profusion of pine-
covered islands along the coast near his native Sendai.

 Despite Obata's apparent artistic aptitude, Rokuichi envisioned a career
in the military for his adopted son, enrolling him in an academy for officer

Mono Lake shows a maidenly beauty
when it is still and quiet. Trembling, the
lake awaits the approaching rain, the
clouds of which hover over the distant
mountain ridges.

Before the Rain, Mono Lake, 1930.
Color woodblock print, 11 x 15¾ in.

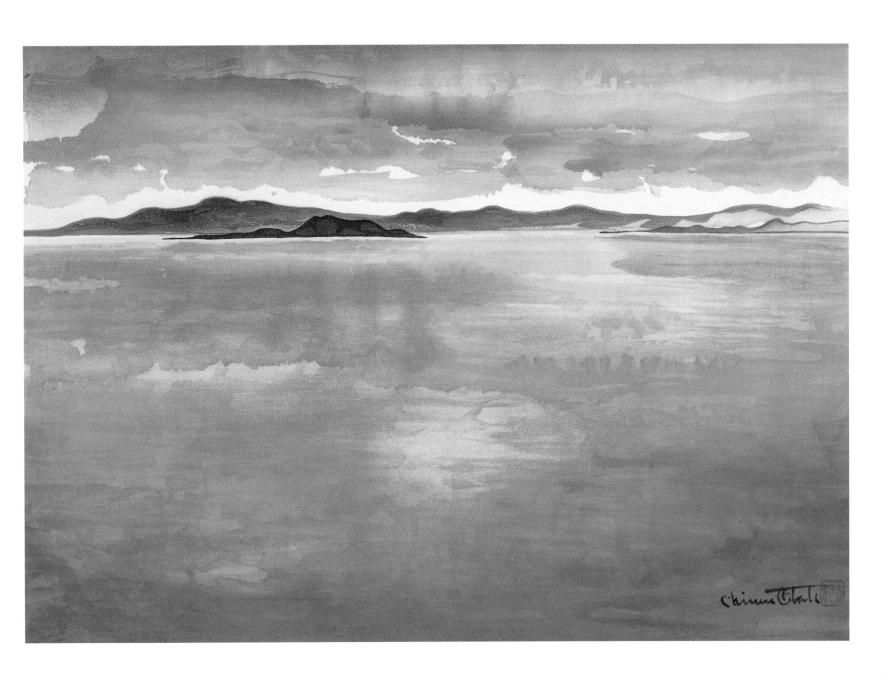

training. The decision proved fateful; at the age of fourteen, Chiura determined to run away from home. With the help of his stepmother, he fled Sendai on a night train to make his name as an artist in Tokyo.

Turn-of-the-century Tokyo was a tempestuous place, with a dizzying number of rival factions in the artistic community. At the center of the debates among the various camps was the issue of Westernization. Since the opening of Japan to the West in 1854 after more than two hundred years of seclusion, the Japanese government had been engaged in the wholesale importation of Western culture to speed the nation's modernization. This campaign extended to the fine arts, and a Europeanized style of oil painting became the official style. In the late nineteenth century, however, just when it appeared that the traditional schools of painting were permanently outmoded, reactionary forces set in, fueled by a tide of nationalism that swept through Japan around the time of the Sino-Japanese War (1894–95). A number of societies and artist groups sprang up to promote a return to Japanese-style painting. Negotiating a middle ground was the American educator Ernest Fenollosa, then teaching at Tokyo University. Together with his protégé, Tenshin Okakura, Fenollosa forcefully argued against the uncritical embrace of Western art and advocated instead a modern *nihonga* (literally, "Japanese painting"), a new approach that would incorporate aspects of Western expression such as modeling and atmospheric perspective, while adhering to an essentially Japanese aesthetic.

Obata became involved with Fenollosa's *nihonga* movement almost from the very moment he arrived in Tokyo in the spring of 1899. Within months he was studying with Tanryo Murata at Okakura's newly established Japan Fine Arts Academy (Nihon Bijutsuin), a private school for *nihonga* artists, and learning an updated variation of the Tosa School, which concentrated on literary subjects and methods descending from the art of ancient Japan. Obata assisted Murata with several major commissions, including the painting of sixty screens for the Konpira Shrine on Shikoku Island. In 1900 he joined the Kensei-kai, a group of younger *nihonga* artists.

It may have been through this affiliation that he met and studied with Gahō Hashimoto, one of Fenollosa's closest associates and a leading painter of the modern Kanō School, which combined the Song and Yuan traditions of Chinese ink painting with techniques derived from British Pre-Raphaelitism. As opposed to the Japanese custom of artistic subservience, Hashimoto encouraged individuality. He is reputed to have urged his students to "copy everything good" but to "imitate no one," advice that Obata seems to have absorbed well.[4]

One of the few extant works by Obata from this period demonstrates

that he had assimilated the teachings of both Murata and Hashimoto. The painting, drawn with sumi and watercolor on silk, depicts a mounted feudal lord in full regalia. Its scrupulous historical accuracy, down to the details of the sixteenth-century armor and horse's fittings, suggests the influence of the Pre-Raphaelite-inspired Hashimoto, while its exceedingly delicate handling of line can be traced to Murata, who was famed for his mastery of the hair pen, a brush made of mink whiskers that could draw a line so fine that it was nearly invisible.

Given Obata's numerous marks of success, including a prestigious medal in the annual Ueno Park competition, it is perplexing that he would opt to leave Japan for the United States. Perhaps he feared the prospect of conscription into the Russo-Japanese War, which erupted in 1904, shortly after he left Japan. Or he may have been drawn by the promise of employment opportunities for artists in California, routinely exaggerated in Japanese travel guides. One guide of the day conjured images of gold, silver, and gems scattered on the streets of San Francisco, assuring that "anyone skilled in the least in the Japanese arts . . . can earn a lot of money by making fans, ceramics, and lacquerware."[5]

Obata must have been severely disappointed with the San Francisco he encountered on his arrival in 1903. Far from the rapturous accounts of earthly paradise reported in Japan, California offered the most inhospitable environment imaginable for the Japanese immigrant. Obata arrived just as a groundswell of xenophobia was beginning to threaten what security the Japanese community had attained during its two decades of existence. The source of the antagonism was largely economic. The Japanese tended to be highly efficient farmers, and their intensive agriculture methods, perfected in Japan where every inch of land had to be made to yield as much as possible, were tremendously successful in fertile California.[6] By the turn of the century, in some parts of the state, Japanese farmers were beginning to dominate medium-scale truck agriculture. As a result, large-scale growers and their political allies—including the powerful AFL—began to agitate against them.[7] In 1905 M. H. de Young's *San Francisco Chronicle* launched a campaign to "cleanse" the North American soil of the Japanese presence. In an article entitled "Japanese Invasion: The Problem of the Hour for the United States," the *Chronicle* argued that the Japanese threatened the American way of life: "Removed by an abyss of tradition, of custom, and sentiment . . . the Asiatic can never be other than an Asiatic, however much he may imitate the dress of the white man, learn his language, and spend his wages for him."[8] Talk like this was incendiary, prompting a spate of violent attacks against the Japanese community. In the first

few years Obata spent in San Francisco, he was assaulted and spit on by strangers in the streets. Such racial animosity continued almost unabated until the Immigration Act was amended in 1924 to eliminate all further Japanese immigration to America.

In a climate of such intense hostility one would expect to find little interest in Japanese art, but it is among the ironies of the Asian experience in the United States that ethnic prejudice coexisted with aesthetic admiration. Japonisme, the appreciation and acquisition of things Japanese, while slower to catch on in cities of the western United States than in Paris, Boston, or New York, became fashionable among wealthy San Franciscans in the early 1910s. This first phase of Japonisme focused on exotica rather than on Japanese philosophy and aesthetics, creating a market for the Japanese decorative arts in California. Consequently, Obata's Western-influenced *nihonga* painting initially attracted little interest, but he was able to secure commissions for traditional Tosa- and Kanō-style screens and murals for the Oriental display rooms of some of the leading department stores in San Francisco, notably J. T. Marsh, Gump's, and the City of Paris. Commissions such as these continued for much of his career, and included stage sets for the San Francisco Opera's staging of *Madama Butterfly* in 1924.

Until the late 1920s, however, Obata's primary economic support came from illustration work for Japanese-language newspapers and magazines. Japantown, the Japanese settlement in San Francisco's Western Addition, provided his initial artistic milieu. Yet even there Obata was something of an anomaly, for most Japanese artists working in California had come to study Western art, and their painting generally reflected the Barbizon and tonalist styles popular in California well into the 1910s.[9] Obata was thus among the very few who worked in Japanese ink and watercolor rather than in oils on canvas.

Obata appears to have kept in close touch with Japan in the 1910s, so that much of his noncommissioned work from that time paralleled artistic developments in Tokyo.[10] *Mother Earth*, a colored-ink painting on silk scroll dated 1912, is characteristic of the *moro-tai* style then fashionable among *nihonga* artists in Taisho-period Japan, such as Tenshin Okakura and Shunso Hishida. Roughly translated as "ultra-impressionistic," *moro-tai* was a good deal less linear than traditional Japanese schools of art, often making liberal use of the Western techniques of modeling and shading. Yet the overall effect was hardly one of realism. Obata's painting, with its orange sky and turquoise-flecked trees, displays the decidedly unnatural use of color that was typical

Mother Earth, 1912.
Watercolor on silk, 86¾ x 58½ in.

of this style. His choice of subject, too, shows that he was current with the latest trends in Tokyo, as the female nude was then a new and controversial theme in Japanese painting.[11] Obata probably intended this work, like much of his early painting, for exhibition and sale in Japan; before the 1920s, there seems to have been little interest within the San Francisco art community in painting that fused Asian and Western styles to such modern effect.

Much of this began to change with the founding of the East West Art Society in 1921, which decisively marked Obata's entrée into the contemporary California art scene. It is not clear how the society began, but the idea appears to have been conceived by Obata and several other Japanese-born artists with modernist inclinations, including George Hibi and T. Hikoyama.[12] Patterned closely on Ernest Fenollosa's vision of an East-West synthesis in the arts, the society called for a union of the best of the Oriental and Occidental traditions— not just in painting but in music, theater, and literature.[13] By 1922 there were at least twenty-seven American, Russian, Chinese, and Japanese members of the society. Its roster included a number of ascendant California painters—notably Perham Nahl, Ray Boynton, Constance Macky, Spencer Macky, and Lee Randolph—artists who would soon be among the leaders of Bay Area painting. And the society had at least two exhibitions at the San Francisco Museum of Art in the space of a year, both meeting with general critical acclaim.

Obata's association with the artists attached to the East West Art Society was crucial to the development of his career; if it were not for his friendship with Nahl, for example, it is doubtful that the art department of the University of California at Berkeley would have hired him. But more significant than the professional connections was the possibility of community—if not the sense of belonging, then at least the feeling of acceptance—that came out of Obata's involvement with the society. He must have been particularly encouraged about the promise of appreciation for Japanese art when he read the letter that J. Nilsen Laurvik, director of the San Francisco Museum of Art, sent to Obata's wife, Haruko Obata, about her exhibition of Japanese floral arrangements the society had organized at the museum in 1922. After the close of the show, Laurvik wrote:

> Your art has been to the most discerning of us a revelation not only of sheer beauty but of those animating principles of design and color that we are slowly coming to understand are the fundamental characteristics of all your art, whether it be painting, music, poetry or flower arrangements, and in so doing, you have opened our eyes to one of the most valuable things in the realm of art.[14]

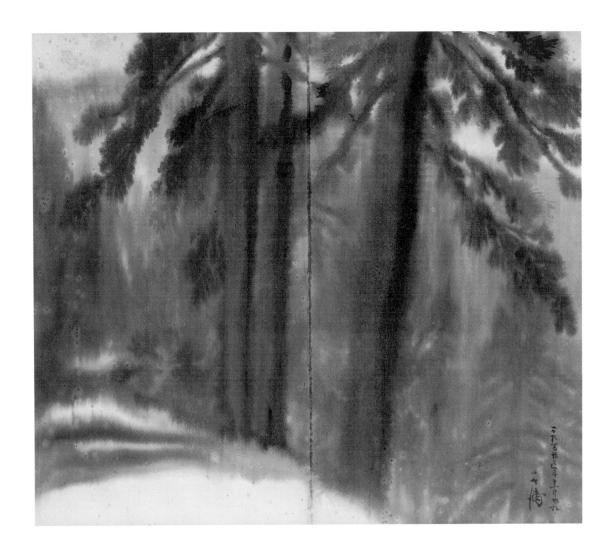

Untitled (Alma, Santa Cruz
Mountains), 29 November 1922.
Sketchbook, sumi on silk mounted on
boards, 14¼ x 16½ in.

Such praise was exceedingly rare at a time when Japanese immigrants
were not allowed to own land in California and were routinely barred from
hotels and restaurants. Laurvik's words suggested that the realm of art might
offer an exception to the racism Japanese Americans experienced in California.
Indeed, Obata was becoming convinced that he could paint for other than an
exclusively Japanese audience, and it was perhaps inevitable that landscape, so
central to both the Japanese and Californian artistic traditions, would provide
the particular vehicle for transcending the cultural boundaries that had seemed
so insurmountable. Obata had, of course, sketched and painted the California
landscape before. In fact, he may have been the sole artist given permission
to produce on-site paintings of the 1906 San Francisco earthquake.[15] But
it was only in the 1920s that the California landscape became his central
preoccupation.

Obata spent much of the 1920s traveling up and down the length of California, painting coastal and interior landscapes as far north as Eureka and as far south as Pasadena. During this period he experimented with diverse styles and techniques, ranging from meticulous realism to an abbreviated impressionism that could summarize a seascape with two or three strokes of the brush. Among the more interesting techniques he used and one that would continue to be of importance to his work was the wet-on-wet application of sumi to capture the effects of heavy mist. The technique imparts a somber, introspective mood to the stand of Santa Cruz mountain redwoods, much like the shady forest glades of Corot and Rousseau. Obata also liked to paint the fog-enshrouded coast of California. During the 1920s he made numerous trips to the Monterey peninsula to paint the rugged coves and jutting promontories of the shore. Point Lobos, long a favorite theme of California artists, held special appeal for Obata, as its deep blue waters and twisted cypresses were reminiscent of his native Honshu.

The redwood groves and rocky coastline of California would continue to fascinate Obata, and he would return to them again and again throughout his long career. But the theme that became his greatest source of inspiration—indeed, a consuming lifelong passion—was Yosemite. It was during a trip to the High Sierra in the summer of 1927 that Obata's prodigious knowledge of Eastern and Western art finally coalesced. Obata himself described this event as "the greatest harvest of my whole life and future in painting."[16] Obata came into his own with the Yosemite watercolors of 1927 and the woodblock prints that were made from them in 1930.

PARADISE RECOVERED: OBATA'S YOSEMITE

Obata's pivotal expedition to Yosemite Valley began with an invitation from Worth Ryder, a newly appointed professor at Berkeley's art department and an inveterate hiker of the Sierra Nevada. Ryder was among the handful of California artists acquainted with modern European art, having spent several years studying abroad, including a summer with Hans Hofmann. (He would later be instrumental in introducing a Hofmann-inspired modernism that was highly influential at Berkeley.) At the last minute, they were joined by another Bay Area modernist, the sculptor Robert Boardman Howard, who had come to finish a mural for the lobby of the new Ahwahnee Hotel. The trio met in Yosemite Valley and set off on a journey by donkey and Model T to the upper reaches of the High Sierra that would last nearly two months. Howard and

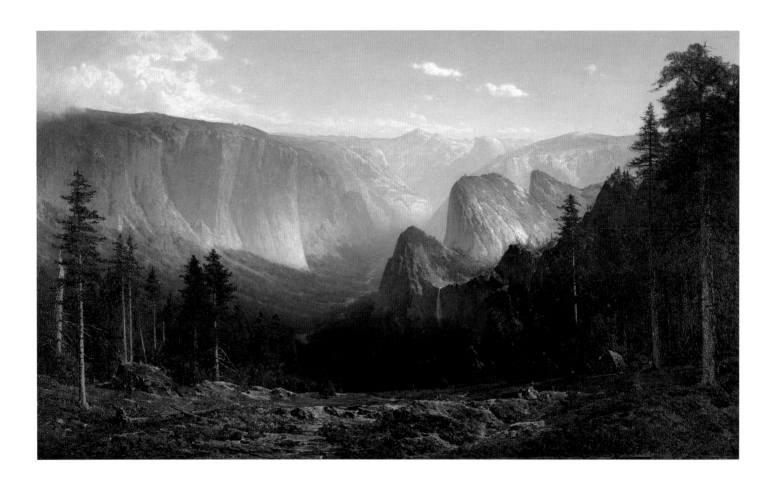

Ryder brought back a few sketches, but for Obata, the trip resulted in as many as 150 sumi drawings and watercolors.

 The natural wonders of Yosemite Valley had, of course, long been a source of inspiration for painters, photographers, and poets. Since its discovery in 1851, the massive valley walls, sheer elevations of glacier-sculpted granite, and scenic waterfalls and alpine forests had been an irresistible magnet for California's residents and visitors alike. Most early portrayers of Yosemite, such as Thomas Hill, Thomas Moran, Carleton Watkins, and Eadweard Muybridge, emphasized the spectacular drama and geologic marvels of the landscape. Theirs was, to some extent, a reportorial vision designed for a curious eastern audience. It was, however, Albert Bierstadt who was most responsible for turning Yosemite into a national icon. Filled with religious allegory and infused with an air of transcendental sublimity, Bierstadt's monumental panoramas depicted Yosemite as at once an idyllic New Eden and a symbol of America's considerable territorial wealth. This brand of inflated, grandiose oratory could only last so long before lapsing into tedious cliché. By the 1880s, Yosemite had

Thomas Hill,
Great Canyon of the Sierra, Yosemite,
1871.
Oil on canvas, 72 x 120 in.
Crocker Art Museum, Sacramento,
Calif.

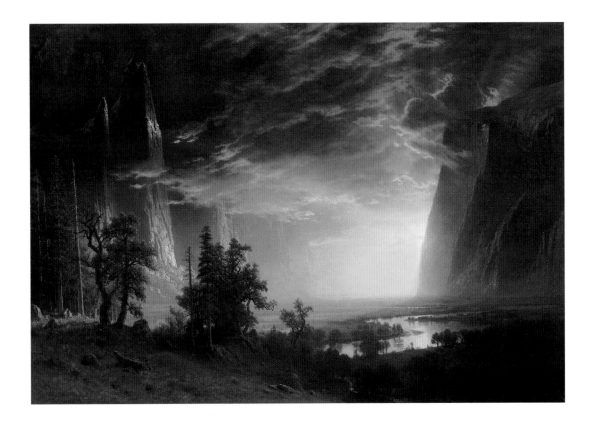

Albert Bierstadt,
Sunset in the Yosemite Valley, 1868.
Oil on canvas, 36¼ x 52¼ in.
Haggin Collection, The Haggin
Museum, Stockton, Calif.

spawned a virtual industry of sentimental painting and verse that continued well into the present century.[17] The result was that many serious painters shied away from the theme, having reached the conclusion with William Keith that Yosemite was "unpaintable."[18] In 1885 an art critic for the *San Francisco Chronicle* proclaimed that "the day for painting Yosemite pictures is over."[19]

This was still the case when Obata arrived in Yosemite in 1927. At that time, most of the painters who ventured to capture the charms of the Sierra were illustrators working in a cloyingly sweet and outmoded style of academic realism. It took an artist such as Obata, someone with an entirely fresh perspective and approach, to breathe life back into what had become a stale and tiresome subject. Obata began by steering clear of the stock themes and devices of his predecessors. Notably absent from his work are the sweeping vistas of the seven-mile-long Yosemite Valley, with its multiple waterfalls, domes, and spires. Although he painted some of Yosemite's famous landmarks—including El Capitan and Yosemite Falls—Obata tended to stress their quiet majesty rather than their awe-inspiring grandeur and scale. Obata preferred unassuming views:

page 47

page 127

a sylvan thicket, a nameless lake, or a sprinkle of wildflowers in a dry ravine. His appreciation for the intimate side of the Sierra Nevada calls to mind the photography of Ansel Adams, who was simultaneously shaping his artistic response to Yosemite. It is not surprising that the two recognized each other as kindred spirits when they met in the early 1930s, and in later years spent time together in Yosemite Valley.

Among the things Obata and Adams shared was a deep admiration for the writings of John Muir. It was one of Obata's great regrets that he had not been able to meet the naturalist before his death in 1914. Like Muir, Obata believed that in order to understand the great scheme of nature one had to study its smallest features. He found enormous pleasure in observing the peculiar flora and fauna of the Sierra, taking a naturalist's interest in the glacial and volcanic rock formations, the different growth patterns of the sugar pines, the great silver firs, junipers, hemlocks, and especially the majestic sequoia, the tree Muir aptly named "king of the conifers."[20] Obata particularly loved to study the abundant varieties of flowers adorning the mountain heights. His watercolors of wild chrysanthemums, columbines, and shooting stars are rendered with a careful eye to botanical detail, much in the manner of Dutch-influenced *kacho-ga* painters of the Shijo School. Yet as one astute reviewer noted, "One cannot justly call any of Obata's paintings a 'still-life.' While preserving characteristic Japanese delicacy of form, he nonetheless instills a delightful vitality into his most humble subjects."[21]

pages 82, 83

As much importance as Obata attached to the specific facts of nature, he did not aim for topographic precision. Indeed, he intensely disliked the documentary realism of much California landscape painting during the 1920s, calling it "stew-pot art," suggesting that just about everything was thrown in the pot. Obata's lack of tolerance for this sort of painting was surely influenced by his youthful involvement with the effort of the *nihonga* movement to purge Japan of its infatuation with Western realism, which became fashionable during the Meiji Restoration. Literal transcription was an alien concept in Japan, as it was to the European modernism embraced by many *nihonga* artists. Obata would later tell his students: "Just to imitate or depict an object or some part of nature is not enough [to] bring forth any beauty or truth of humanity. . . . In expressing our minds, there must not be for a moment the slightest thought of dependence or imitation." He liked to relate to his classes a story he had heard in Japan of a blind man who could paint with unsurpassed feeling and imagination. Obata espoused a fundamental ideal of Zen Buddhist painting known as *kiin-seido*, meaning "living moment," the immediate, intuitive

expression of the subject's essential nature. *Kiin-seido*, much like the German expressionist tenet of *Einführung* (empathy), requires a close identification with the thing depicted. Before attempting to paint natural subjects, the Zen artist typically spent many hours in solitude clearing his mind and studying the minute particulars of nature's forms. Only after lengthy preparation, in some cases lasting a lifetime, could the artist hope to achieve an intuitive

Untitled (Landscape), 28 July 1927.
Sumi and watercolor on paper,
11 x 15¾ in.

understanding of the 'life movement' or 'spirit harmony' at the essence of all living things. As the scholar of Chinese art Michael Sullivan has observed, "What the [landscape painter] records is not a single confrontation, but an accumulation of experience touched off perhaps by one moment's exaltation before the beauty of nature."[22]

Obata did not go so far as to disregard the physical aspects of nature entirely. His conception of space in most of the watercolors and drawings from his 1927 trip is essentially Western. In works such as *Untitled* (Landscape) he has mastered the precise location of elements in space and their unification by means of atmospheric and logical relationships in scale. Yet Obata subscribed to an important canon of Japanese painting—*esoragoto*—which holds that great works of art rely more on fictions from the artist's imagination than on visual reality. Consequently, his forms are highly simplified: rocks and trees are frequently indicated by heavy black lines, while broad summarizing strokes of paint merely suggest the presence of foliage. And Obata occasionally took liberties with the geography of familiar Sierra landmarks, rearranging mountains, rivers, and lakes at will.

At variance from Japanese traditions, however, was Obata's refusal to follow a single identifiable style or school (although it should be noted that Sesshu, the Zen monk-painter whom Obata greatly admired, was similarly inclined). Obata quite explicitly denied affiliation with any particular school. "I paint nature," he once said, "not as if I were a classical, or a Cubist, or an Impressionist, but simply as I see her loveliness."[23] Indeed, his working process was generally consistent—careful study of the subject followed by spontaneous, unhesitating execution—but his style varied from day to day, depending on his mood and the particular demands of the landscape. For many of his Yosemite watercolors, Obata combined an expressive calligraphy with soft washes of paint, generally in a cool mineral palette of Prussian blue and emerald green warmed by salmon pinks and ochers. But his brushwork ranged dramatically. At times, Obata used the delicate, undulating line beloved of Tosa artists; on other occasions, he employed the short, choppy brushwork known as the *shin* style of Japanese painting and calligraphy. In *New Moon, Eagle Peak* Obata appears to have used still another technique, known in Japan as *hatsuboku*, or "flung ink." This style is generally associated in Japan with Zen artists such as Sesshu and consists of broad, freely applied brushstrokes that often run or spread owing to their liquid, rapid-fire application. In *New Moon* Obata imparts a quiet poetry to a moonlit mountain, suggested by only a few swift strokes of the brush.

page 29

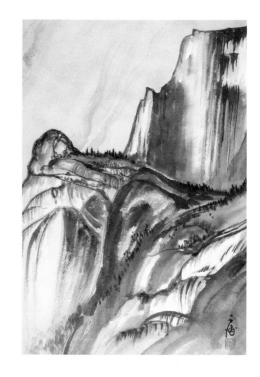

Half Dome, 1927.
Sumi and watercolor on paper,
15¾ x 11 in.

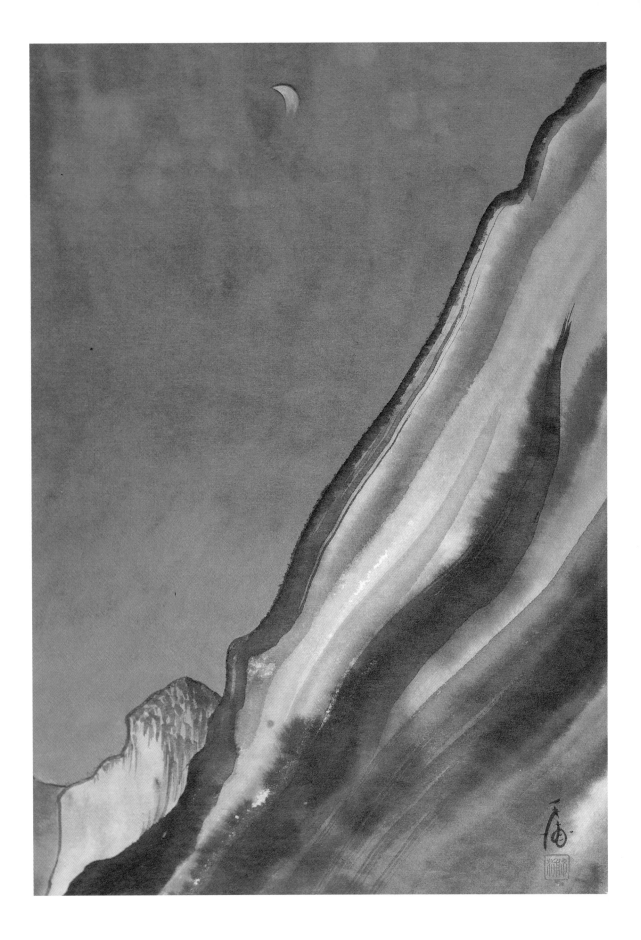

New Moon, Eagle Peak, 1927.
Sumi and watercolor on paper,
15¾ x 11 in.

*Upon the clear, mirrorlike sky appear
lumps of rain clouds, which sail
speedily over the mountains watering
all things beneath as they go by and
refreshing all.*

Passing Rain, 1930.
Color woodblock print, 11 x 15¾ in.

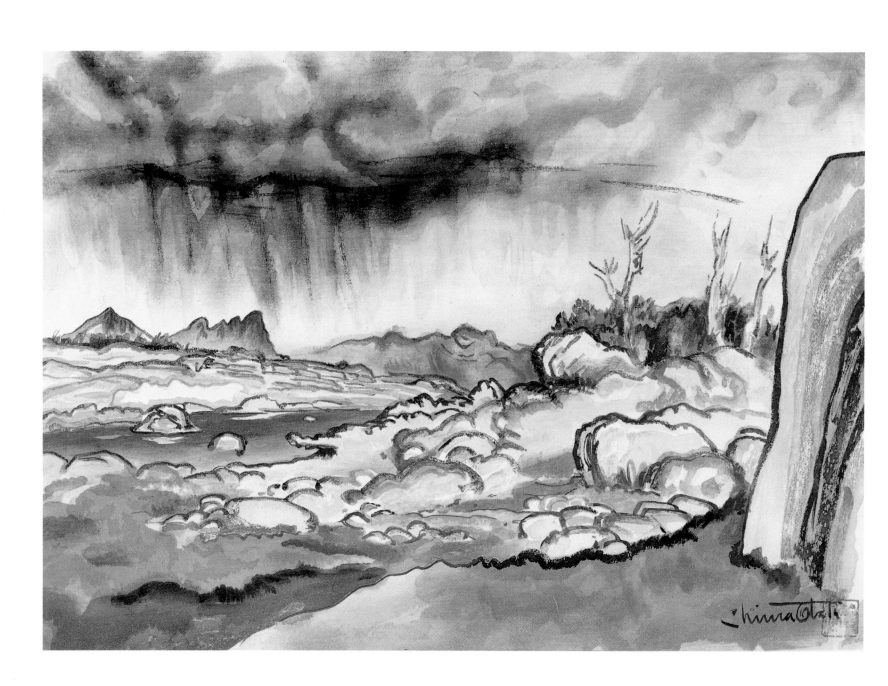

Some of Obata's Yosemite watercolors (and their corresponding woodblock prints) do not relate to any tradition of Japanese painting at all. Works such as *Before the Rain, Mono Lake* suppress calligraphy altogether, relying instead on washes of wet, saturated paint contrasting with thinly painted or exposed areas of paper, much like paintings by the later California Watercolor School artists Alexander Nepote, Tom Lewis, and Stan Backus. In *Before the Rain* Obata has captured the gentle beauty of Mono Lake just moments before a shower, a daily afternoon occurrence in the High Sierra during the summer months. A feeling of dampness pervades the scene, making the sense of impending rain almost palpable.

page 19

Obata painted the Sierra Nevada at various times of day and in various conditions of weather, but afternoon rainfall was among his favorite themes. As it did for Muir, who wrote so eloquently of summer squalls in the Sierra, rain became a symbol of spiritual renewal for Obata. Yosemite's crystalline bodies of water also epitomized the restorative, purifying properties of nature. Obata especially cherished the silence and tranquility of the high mountain lakes. "When faced with such serene beauty," he once remarked, "the soul and mind of man are lost, the possibility of petty thought vanished." For Obata, the Sierra lake became a metaphor for the egoless state of mind sought by the Zen masters. "Our mind must be as peaceful and tranquil as a calm, undisturbed lake," he would later write. "Let not a shadow be cast on it with the slightest thought of self-conceit or Egotism. . . . Only thus can a genuine art, overflowing in deep praise and abiding inspiration, be produced."

Alexander Nepote,
Untitled (Fog in the Hills), n.d.
Watercolor on paper, 15 x 22 in.
Courtesy of Westphal Publishing.

If the deep serenity of Yosemite became an important theme for Obata, he was equally drawn to the teeming life of the Sierra. He seems to have been less concerned with rendering the isolated elements of the mountains than a holistic vision of their shared 'spirit harmony' or 'life rhythm.' For Obata, like the Zen landscape painters he admired, all elements of nature "breathe" a common spiritual energy, endowing them with a profound sense of unity. To express this interrelatedness, Obata infused his paintings with a feeling of movement. In the watercolor entitled *Lee Vining Creek Trail*, for example, kinetically charged forms are repeated throughout the composition. By limiting himself to a few colors and related shapes, Obata hoped to create a rhythm that would express his vision of nature's continual vibrations. Here, the jagged contours of the clouds echo the craggy edges of the mountains. Obata seems to have had Muir in mind when he painted this work, for he has re-created Muir's vision of "glorious pearl and alabaster clouds"—those "fleeting mountains of the sky." [24]

page 34

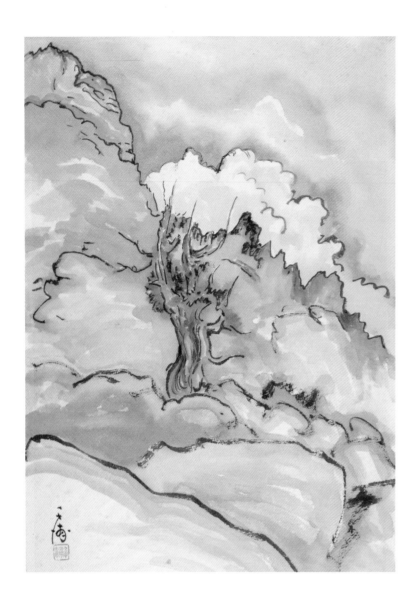

Lee Vining Creek Trail, 24 July 1927.
Sumi and watercolor on paper,
15¾ x 11 in.

Lee Vining Creek Trail also contains intimations of a theme that would become central to Obata's work: the stamina of the storm-weathered tree, a symbol that expressed Obata's own endurance of the painful and humiliating discrimination he continually encountered in California and, by extension, a metaphor for the issei, the first-generation Japanese immigrants, who despite almost unbearable hardships, prevailed in setting down roots for their children in America. The greatest need for strength was still to come with the evacuation of all residents of Japanese descent living on the West Coast to concentration camps during World War II. Yet even behind barbed wire, Obata returned to Yosemite, if only in his imagination, to recover a world of untroubled natural beauty.

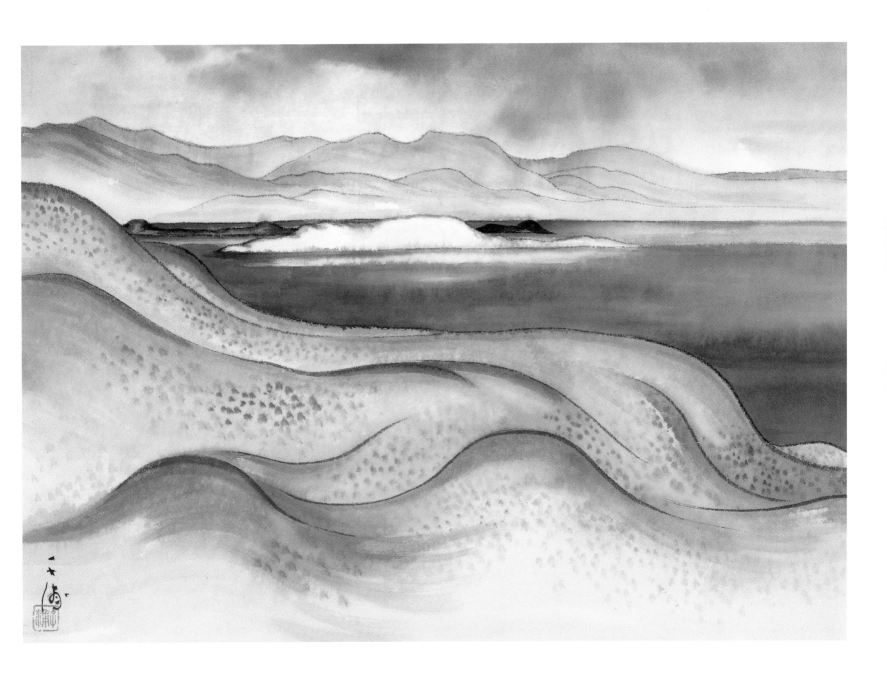

Along Mono Lake, 1927.
Sumi and watercolor on paper,
11 x 15¾ in.

A quiet hamlet on the banks of the
Stanislaus River in the Sierra foothills.
Here a restful night was spent camping
by the side of the famous Big Oak Flat
Road, which runs from Oakdale to
Yosemite. The cackling of chickens
had awakened the sleeper to behold
the dawn.

Dawn, Knights Ferry,
Stanislaus County, 1930.
Color woodblock print, 11 x 15¾ in.

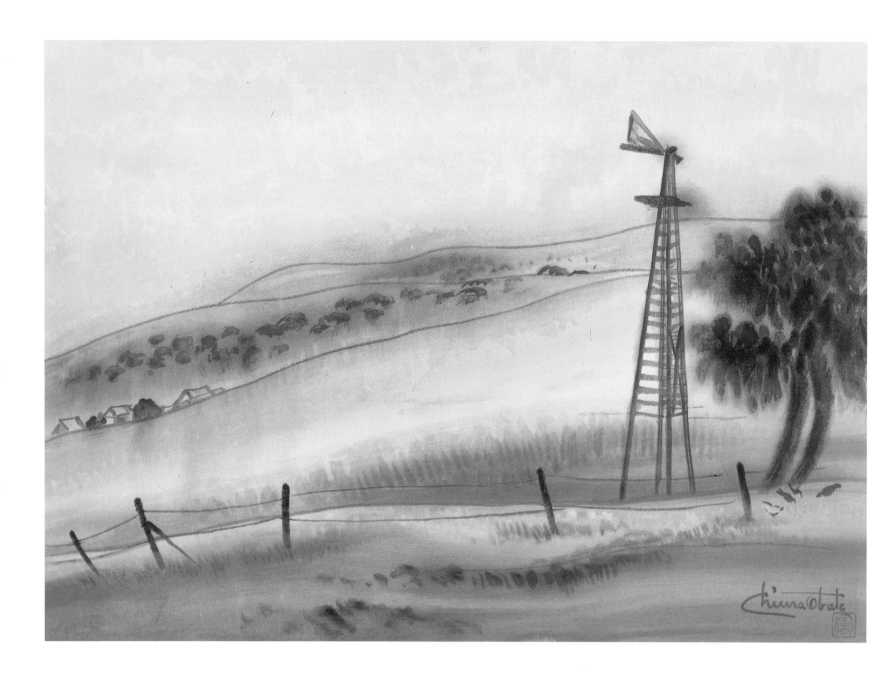

In March 1928 Obata was given his first one-person show since his immigration to America, at the East West Gallery of Fine Arts in San Francisco. It is indicative of the importance Obata attached to his Yosemite watercolors that a good number were included in the exhibition. The local newspapers reported that he had made his selection from more than ten thousand paintings and sketches accumulated over a twenty-year period. Obata told at least one critic that he had waited to show his work out of the belief that, as his master Tanryo Murata was fond of observing, "an artist has nothing to say until he has painted at least a thousand paintings."[25]

The reception of Obata's first show was mixed, with some reviewers perplexed by his abbreviated watercolor style. But just two years later, in 1930, Obata's exhibition at Gyosei Hall in San Francisco drew capacity crowds and ecstatic reviews. The latter exhibition featured fifty watercolors, mostly from his trip to the Sierra in 1927, accompanied by thirty-five woodblock prints that had been made from them during a trip to Japan in 1928–30. Viewers marveled at the technical virtuosity of the prints, which reproduced every stroke and nuance of the watercolors to perfection. As Janice Driesbach's essays in this volume attest, these prints were unique even in Japan, with its three-hundred-year-old tradition of woodblock carving. The exhibition proved so popular that several other galleries requested it. In 1930–31 the show traveled a circuit that included Haviland Hall at the University of California at Berkeley, the California School of Fine Arts, the California Palace of the Legion of Honor, Courvoisier Gallery, Mills College (where gallery officials had trouble closing the show), and the Stendahl Gallery in Los Angeles.

Obata's sudden celebrity was due not only to his extraordinary woodblock prints but to the rise of the California Watercolor School, through which watercolor was beginning to eclipse oil painting as the dominant mode on the West Coast. Spearheaded by the Los Angeles artist Millard Sheets, the California Watercolor School began in the late 1920s as a variant of American Scene Painting with an emphasis on picturesque rural and coastal views of California. By the early 1930s the number of watercolor practitioners had swelled, as artists such as Dong Kingman, John Haley, and George Post in the North joined Phil Dike, Barse Miller, and Paul Sample in the South. What distinguished their painting was their restraint from using the more deliberate British methods employed by most American watercolorists. Rather than laying pale washes over prepared drawings, many of these artists applied vivid colors to the paper directly. As the *Los Angeles Times* art critic, Arthur Millier, wrote:

Erle Loran,
Foot of Hyde Street, 1940.
Watercolor and gouache on paper,
16 x 21¼ in.
The E. Gene Crain Collection.

They have escaped the solemn near photography which dulled so many of our oil paintings. The flowing lines and glowing, transparent washes of water color are more apt to record feeling than facts. The characteristic of our whole "school," North and South, is the swift, joyous expression of a delighted moment.[26]

That Obata's painting reflected this new aesthetic was not lost on local critics, who often noted his "modernist" stress on immediacy. It had, in fact, been the modernists all along who were most receptive to Obata, and the galleries that initially showed his work—Courvoisier and the East West—were both committed to promoting modernism.[27] Of course, the affinity was natural, since Japanese art had been an important formative influence on the early European modernists. This connection was rediscovered, it seems, by some of Obata's most ardent champions, such as Jehanne Bietry-Salinger of the *Argus* and Anna Sommer of the *San Francisco News*.[28] In a review of Obata's show of Yosemite prints and paintings at the Courvoisier, Sommer exclaimed:

Of all influences permeating the creative art of today, none is more subtle and significant than the Japanesque. . . . The abstracting of the pure essentials of an object, the scorn of photographic realism, the simplicity which rises above details—these and other shibboleths of the modern school were practiced in Japan centuries before the advent of the impressionists, cubists, and futurists.[29]

When Obata joined Berkeley's art department in 1932, he found himself at the Bay Area's headquarters for both modernism and the California Water-color School. The faculty included Ryder, Margaret Peterson, and John Haley, former students of Hans Hofmann; they were soon joined by Erle Loran, who had spent a year living in Cézanne's studio in Aix-en-Provence. Their collective efforts combined cubism, post-impressionism, and contemporary watercolor practices to form what became known in the late 1930s as the Berkeley School.[30] In this setting, Obata flourished as a teacher of freehand painting, encouraging students such as Miné Okubo, Karl Kasten, Ralph DuCasse, and Rex Brandt to use Japanese brush techniques.[31] Obata's spontaneous approach to painting seems to have freed the work of the faculty as well. Ryder was especially enamored of Obata's brush handling, and became a longtime devotee of sumi ink painting.

But while Obata had an important impact on both students and faculty, his own painting remained peripheral to the Berkeley School. Obata took liberties with abstraction, and he admired some of the French moderns—notably

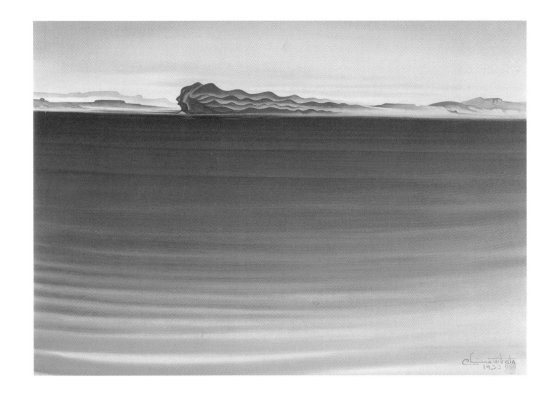

page 37

Matisse and Gauguin—but he never adopted the combination of cubist and Cézannesque traits characteristic of Haley, Loran, and their progeny. He stayed away from the Berkeley School's trademark devices, such as off-register contours and loose, superimposed blocks of color. Most important, Obata's subjects differed from the usual fare of the Berkeley School. Although he made an occasional nod to American Scene Painting—for example, in his portfolio of campus views published in 1939—Obata preferred to paint the natural world. Urban and industrial landscapes, the favored themes of the Berkeley School, rarely appeared in his work.

Much of Obata's painting of the 1930s has a distinctly pastoral feel. Bathed in soft light, scenes of walnut orchards in spring, or the Suisun delta on a warm summer afternoon, have a profoundly calming effect on the viewer. Obata seems to have intended paintings like *Melody of Wave, Pyramid Lake, Nevada* to act as a soothing balm in troubled times. This was the depth of the depression, and for Japanese Americans, it was a particularly bleak period. They suffered unemployment more severe than that experienced by the American population as a whole and were buffeted by another wave of anti-Japanese sentiment after Japan's withdrawal from the League of Nations in 1933. Viewed in this context, *Melody of Wave*, with its smooth expanse of pacific blue, seems a gentle lullaby, sung ever so softly, by Obata's muse of peace.

The color of the water in *Melody of Wave* might be called "Obata blue," so frequently does it appear in his paintings. Obata looked to the Tosa School, whose artists he considered the finest colorists of Japan, for selecting and dissolving pigments. Following formulas some of which were more than a thousand years old, Obata ground his own paints from a variety of materials, including precious and semiprecious stones, flower petals, and oyster shells.[32] For his blues, Obata ground lapis lazuli; for greens, he ground malachite, turquoise, or peacock stone. He is reputed to have used ruby dust for special reds—at a cost of seven hundred dollars for a tiny vial. In one respect Obata never wavered: he insisted until his death on employing the best materials Japan had to offer. His sumi was of a type made in the mountains of Japan from a secret slow-burning carbonization of pine; his brushes were constructed by hand with animal furs such as rabbit, fox, sheep, badger, and bear. Even Obata's water came from the purest sources he could find, preferably mountain lakes and streams. In the 1930s he made pilgrimages to Fern Spring in Yosemite Valley to collect its crystalline water, which he used to mix with his sumi.

As the 1940s began, Obata's fortunes seemed ever-ascendant. His classes at Berkeley were easily among the most popular in the art department, he had several galleries handling his work, and he was exhibiting in annuals throughout the country. In 1942, however, all of this came to an abrupt end. Responding to anti-Japanese agitation whipped up by war hysteria after the bombing of Pearl Harbor, President Franklin D. Roosevelt signed Executive Order 9066, declaring all Americans of Japanese ancestry "enemy aliens."[33] Approximately 113,000 Japanese Americans were herded into armed camps, their property confiscated or hastily sold at a fraction of its value. Obata was among them. In March 1942 he was an esteemed professor at Berkeley; the next month he was living with his family in a horse stall with hay for bedding at Tanforan racetrack, a makeshift detention camp just outside San Francisco.

Obata spent more than a year imprisoned at Tanforan and at Topaz Relocation Center in central Utah. Remarkably, with the help of his old colleague George Hibi, he was able to establish art schools in both locations, using his university and museum connections to obtain supplies for classes in ceramics, painting, and sculpture.[34] The art work produced by the students, who ranged in age from five to seventy-eight, was shown in an exhibition at Mills College in the summer of 1942.[35]

Obata himself also kept busy producing art. Much of his work from this time consisted of sumi sketches chronicling daily life in camp, some of it humorous, some of it deeply poignant. One of his most heartrending paintings

shows an incident in Topaz when an old man was shot by a guard for straying too close to the fence to retrieve his dog. Most of Obata's watercolor paintings, however, focused on the surrounding desert landscape. What was by most accounts a forbidding, inhospitable land—baked by temperatures that reached 110 degrees in the summer and whipped by blinding dust storms—became a thing of beauty in Obata's imagination. By using an airbrush, Obata trans-formed the dust-filled air over Topaz at sunrise into scenes of enchantment.

Early Morning, Topaz, Utah,
June 1943.
Watercolor on paper, 14¾ x 22½ in.

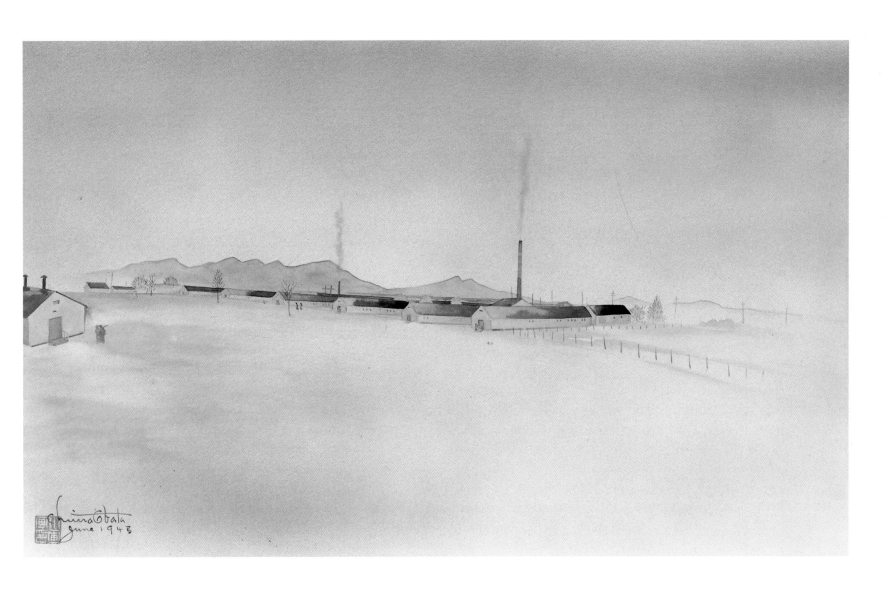

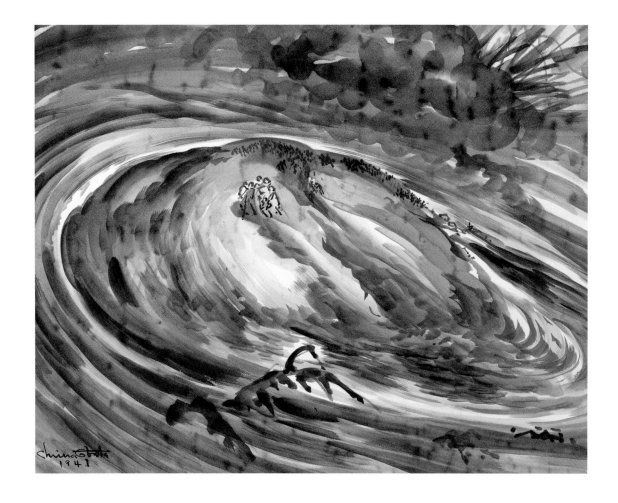

Landslide, 1941.
Sumi and watercolor on paper,
22 x 28 in.

During the war years, the desert wind became a kind of leitmotif for Obata.
Strangely enough, he had anticipated this theme in a work entitled *Landslide*,
just after Pearl Harbor. The painting shows the artist and his family "huddled
together while the vortex of war swirled their foundations away from them,"
as a caption for the work read in a later exhibition. With its agitated brush-
work and explosive, centrifugal thrust, this is probably as close to abstract
expressionism as Obata ever came.

Obata was released from internment in 1943, and after a brief stay in St.
Louis, resumed teaching at Berkeley. Obata's painting in the last decades of his
life followed a steady course. He seems to have reacted to the trauma of the war
by affirming his Japanese heritage and becoming stylistically more conservative.
Until he died in 1975, Obata concentrated on *sumi-e*, much of it without added

color. Paintings such as *Rolling Hills* show his complete mastery of this difficult medium, which permits no corrections or alterations. Many of Obata's late *sumi-e* achieve an austere loftiness of theme, particularly the landscapes of Yosemite, some of which draw from the aristocratic Kanō tradition of ink painting. Like the Kanō painters, Obata relied almost exclusively on his mind's eye for these paintings, distilling his memories and experiences of places that, in some cases, he had not visited in many years.

page 44

A Storm Nearing Yosemite Government Center, February 1939. Sumi on silk, 20⅞ x 32⅝ in.

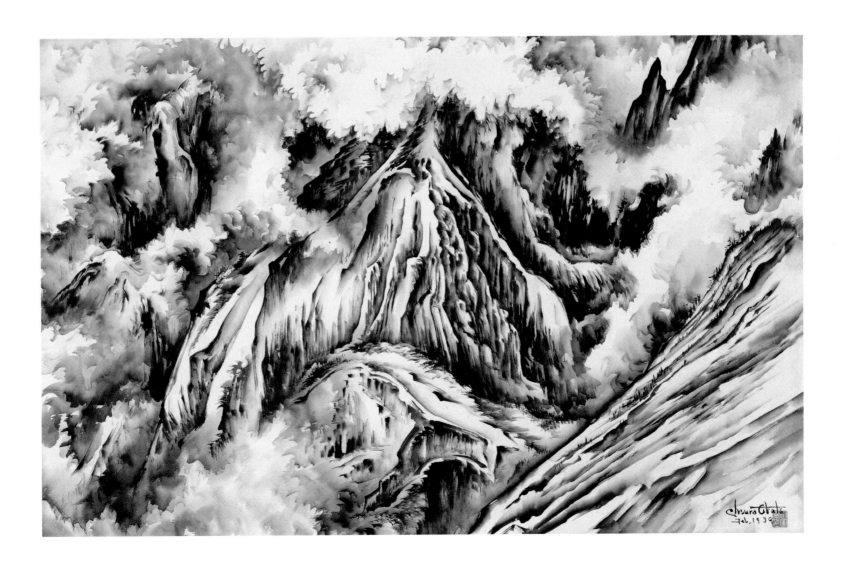

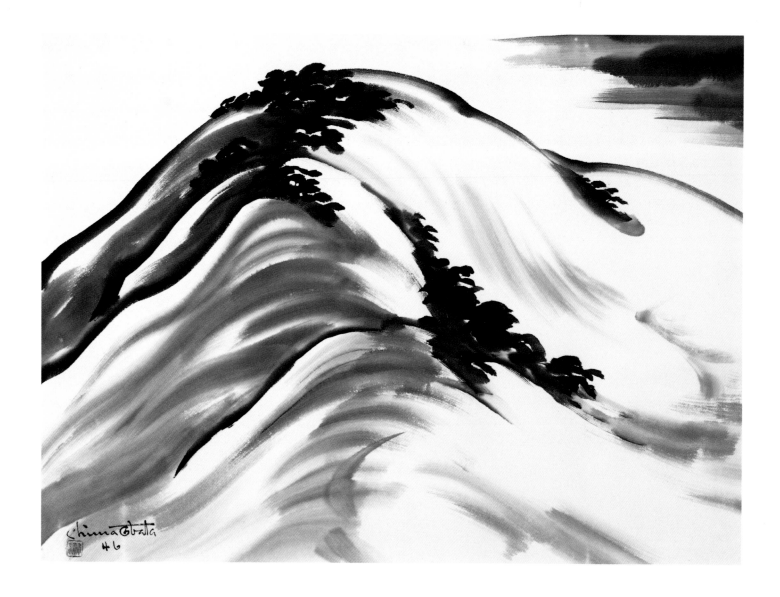

Rolling Hills, 1946.
Sumi on paper, 15 x 20½ in.

Chiura Obata, whose watercolors spanned more than seven decades, lived to see the California Watercolor School rise to national prominence in the late 1930s and its abrupt displacement by abstract expressionism after the war. Ever perfecting his sumi technique, he remained untouched by the art trends that seemed to supplant one another with dizzying speed in subsequent years. Yet, given such perseverance, Obata's style is difficult to decipher. If, in more than a half century of making art, Obata followed a variety of directions, it was because he believed that his education as an artist was never complete. As he said in 1934 at the crest of his popularity, "I am not a 'finished artist.' I shall always be studying . . . until I die."[36]

An individualist, Obata believed in giving free range to his poetic voice and in making the best of his resources, which, encompassing the traditions and innovations of both the East and the West, were vast indeed. Finally, Obata's accomplishment reflects the courage with which he faced the project of being an Asian artist in a hostile society. It was in order to transcend this hostility that he kept his gaze trained so intently on the timeless beauty of the California landscape. Obata's own words express well his implacable faith in art's regenerative capacity, the true raison d'être of his life's work:

> My aim is to create a bowl full of joy
> Clear as the sky,
> Pure as falling cherry petals,
> Without worry, without doubt;
> Then comes full energy, endless power
> And the road to art.[37]

SUSAN LANDAUER is an independent curator and writer specializing in California art. She holds a Ph.D. in art history from Yale University. Her publications include *Edward Corbett: A Retrospective* (1990); an essay in *Clyfford Still: The Buffalo and San Francisco Collections* (1992); and *Paper Trails: San Francisco Abstract Expressionist Prints, Drawings, and Watercolors* (1993); as well as numerous articles.

THE PROSPECT of a return to Japan appears to have been the impetus for Chiura Obata's vision of translating his watercolor views of Yosemite into woodblock prints. In his native country, which had a strong color woodblock printing tradition, he would have access to skilled woodblock carvers and printers capable of attaining the refinements he envisioned. It is possible that Obata had already planned such a trip prior to his father's death in 1928, as he had not seen his family in twenty-five years. If so, he may have made the watercolors during his visit to Yosemite with the intention of using them as models.[1] He was, no doubt, aware of the ample precedents and significant potential for such a project when he set out for the Sierra in 1927. And, Obata's experiences on this visit to Yosemite certainly served as a stimulus for the unusual series of prints.

One influence on this project may have been the Japanese artist Hiroshi Yoshida, who made an extended visit to the United States and Europe beginning in 1923. At this time, Yoshida recognized the market in the West for Japanese prints and made studies of El Capitan, Mount Rainier, and the Grand Canyon, as well as the Jungfrau, Wetterhorn, and Breithorn.[2] The first woodblocks Yoshida had personally supervised, these were published in 1925 as part of a *World Print Series*, a title remarkably similar to the one Obata selected.

Obata may well have met Yoshida during the latter's visit to San Francisco and at that time have learned of plans for the portfolio. He could also have learned about these prints in February 1927, when Kazue Yamagishi, who carved the woodblocks for Yoshida's *El Capitan*, offered a workshop for Perham Nahl's classes at the University of California at Berkeley, which Obata attended.[3]

Six months afterward, Obata arrived in the Yosemite Sierra in the company of Worth Ryder, a painter and printmaker. Ryder had returned to California the previous January to join the art-department faculty at the University of California at Berkeley. His training encompassed study in California as well as at the Art Students League in New York City and the Royal Bavarian Academy in Munich. Obata had probably met Ryder at the

Obata's Vision of Yosemite

page 48

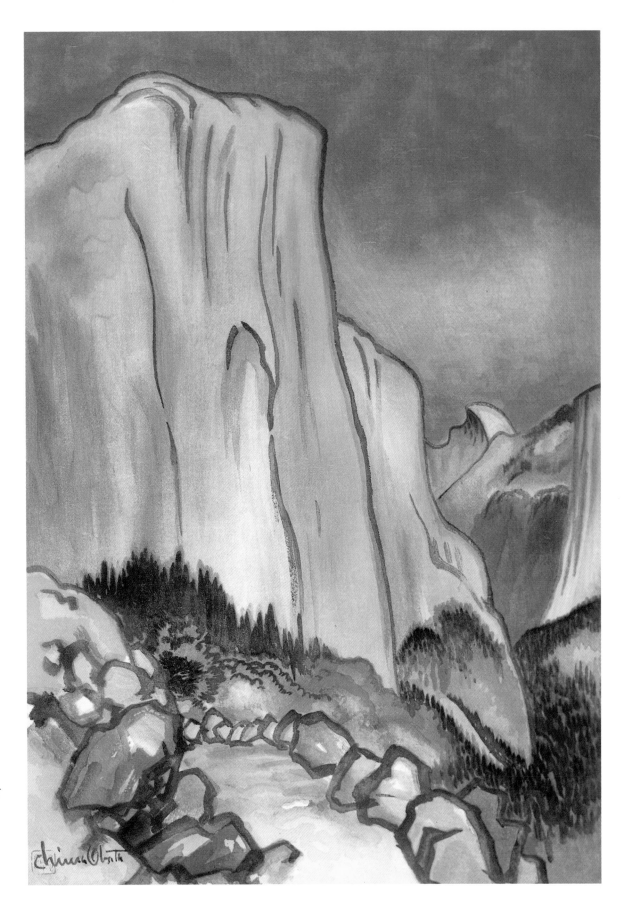

El Capitan, 1930.
Color woodblock print, 15¾ x 11 in.

El Capitan, clad in its peculiar dress of yellow ocher, looks down upon the quiet Yosemite Valley.

University of California through their mutual friend Perham Nahl. A professor of Ryder's, Nahl, presumably, had recommended his student for the teaching position at Berkeley. And, as an enthusiast of Japanese art and culture, Nahl had known Obata since the early 1920s and had invited him to teach classes at the university as early as 1923–24.[4]

A veteran mountaineer, Ryder brought considerable experience in the Yosemite area to their adventure. He had been introduced to the Sierra Nevada as a youth and "at every opportunity traveled this great range from the Mojave Desert to Mount Shasta. His particular love was the stretch from the Kings-Kern Divide to Yosemite, now well known as the John Muir Trail."[5] From 1919 to 1921 Ryder worked "providing equipment and pack trains for travelers in the High Sierra" to earn money to return to Europe, and his skills at climbing the Finsteraare Glacier along the Italian-Swiss border earned him the honor of Swiss Alpine Club membership in 1922.[6] As early as the summer of 1915 Ryder made a print series of the Sierra Nevada, of which he stated: "The originals made at an elevation of 11,000 feet. The first lithographs made of [the] high mountains."[7]

Although it is unsure who suggested the camping trip, Ryder later spoke of his "presentation in 1927 of the Sierra to Obata and of Obata to the Sierra."[8] The two artists, albeit united in their love of nature, made unlikely traveling companions. Obata recorded their experiences matter-of-factly in regular correspondence, while Ryder's single known letter from the journey reveals his strong romantic nature. To judge from surviving evidence and his own accounts, Obata was the more diligent artist, producing more than fifty paintings, as well as numerous botanical studies, genre scenes, and postcards. The two apparently shared a sense of humor. While descending into Yosemite Valley with two pack mules,

> they encountered a group of school teachers. At the sound of "Pack Train," the teachers scattered, like vultures, and as Obata, his head tied with a white cloth, strode past with samurai gait, the awestruck teachers whispered "Who is he? Who is he?"
>
> Ryder, drawing up the rear with the mules, answered, "He is an emissary from the Mikado looking for the most beautiful spot on earth."[9]

In Obata's account of the 1927 Yosemite trip recorded forty years later, he stated that it "was the greatest harvest for my whole life and future in painting. The expression from Great Nature is immeasurable."[10] The Japanese-born artist appears to have arrived in the Sierra with a mission; he was determined to record the wondrous landscapes of Tuolumne Meadows,

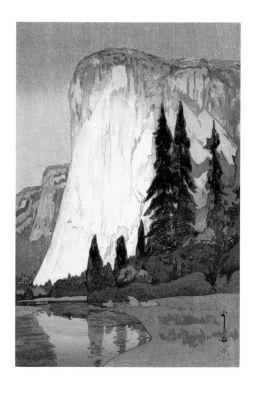

Hiroshi Yoshida,
El Capitan, 1925.
Color woodblock print,
14¾ x 9¹³⁄₁₆ in.
Private collection.

48

Mount Lyell, Mono Lake, and the rest of Yosemite's high country in pencil, sumi, and watercolor. The sculptor Robert Boardman Howard, who joined the party in mid-July, observed, "Every pause for rest saw Chiura at work. That is almost the first impression he gives one, either working or on his way to work; never getting ready."[11] Howard continued:

> Camping that night beyond the head of Yosemite Falls, we sat before the friendly campfire in the cool silence of the high Sierra, and Chiura told us he must paint one hundred pictures during this month of mountain wanderings. The first one would be of Yosemite Falls, for they had spoken to him in music that afternoon on the way up out of the Valley.[12]

By the time Howard joined the party, however, Obata had been traveling with Ryder for more than two weeks and had documented the journey in words and paintings virtually from its outset. Among the earliest dated sketches from this trip are the scenes *Chinese Camp* and *Priest Grade Hill*, made on 16 June 1927. Views of Harden Flat and Aspen Valley Lodge were recorded on the days that followed. Ryder and Obata then entered Yosemite National Park via the Tioga Road, their car laden with "two beds, fourteen boxes of food, painting materials, fishing gear, two suitcases, a tent, a large saw, a large axe, a big shovel, and a big bucket of water in case of emergency."[13] The artists chose White Wolf as their base camp from the latter part of June through early July. There Obata could indulge his passion for fishing, an activity that he engaged in frequently during his stay. More significant, by 1927 Yosemite Valley was already considered crowded during the summer months. As a result, the high country was being promoted as an alternative tourist destination for those seeking a more secluded experience.[14] Obata's letter from 4 July noted that "in Yosemite [Valley] there are so many automobiles and people that when I looked down from a viewpoint I did not feel like leaving the quiet mountains."[15] Although Obata made trips into the valley, including one to meet Robert Howard, these appear to have been relatively rare events. Likewise, few Yosemite Valley scenes are represented in the woodblock print portfolio, which is dominated instead by compositions featuring less familiar views of the High Sierra and Mono Lake.

Around 5 July Obata and Ryder packed up their camping gear and moved to Yosemite Creek, where they stayed about four days and were joined by Howard. The group subsequently traveled on to Tuolumne Meadows. Even though Obata planned to depart Tuolumne on 15 July, he chose to extend the trip, writing that "after knowing this abundant, great nature, to leave here

page 50

page 51

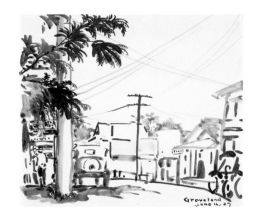

Groveland, 16 June 1927.
Sumi on paper, 9 x 10⅞ in.
Annotated: *Groveland/June 16, 27*

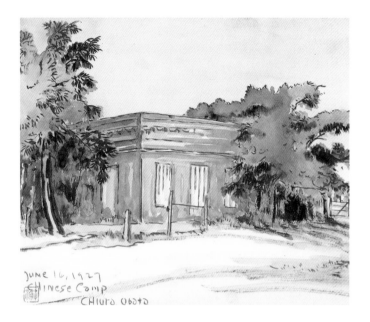 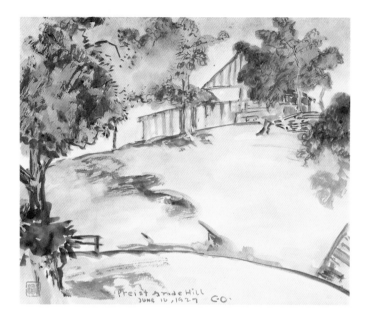

would mean losing a great opportunity that comes only once in a thousand years."[16] The artist had become enamored of the region, and he praised the terrain along the California-Nevada border, noting its distinctiveness from that of Yosemite Valley. In subsequent letters Obata described his ascent of Johnson Peak and his encounters with Mount Dana, Mount Gibbs, and Mount Lyell, all sites that served as subjects of later paintings and prints.

On 26 July Obata reported his departure from Tuolumne Meadows, over Tioga Pass to a campsite at Mono Mills, "behind Mono Lake."[17] From Mono Lake, the group continued to Mammoth Lakes, Lake Mary, and Devil's Postpile, before returning to their "base camp at Lyell Fork in Tuolumne" around 29 July. In his final letter dated 30 July, Obata contemplated his impending departure planned for the following day, writing, "I am full of gratitude as I bid farewell to these Sierra Mountains. From the deep impression of my experience there springs an emotion which others may not understand. I am looking forward with pleasure and hope as to how I will be able to express this precious experience on silk."[18]

That September, Obata spoke to Worth Ryder's classes at the University of California. In comments on the presentation, the *Oakland Tribune* reported that "the artist recently returned from the Sierra Nevada mountains, where he made about 100 sketches. These have been exhibited privately, and it is hoped they will be exhibited publicly at a later date."[19]

Chinese Camp, 16 June 1927.
Sumi and watercolor on paper,
9 x 10⅞ in.
Annotated: *June 16, 1927/Chinese Camp/Chiura Obata*

Priest Grade Hill, 16 June 1927.
Sumi and watercolor on paper,
9 x 10⅞ in.
Annotated: *Preist Grade Hill/June 16, 1927/C.O.*

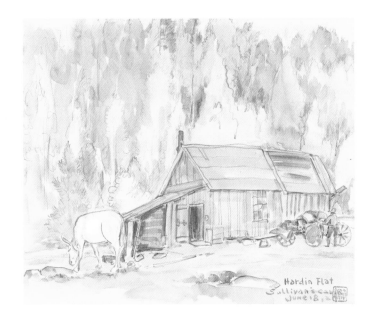

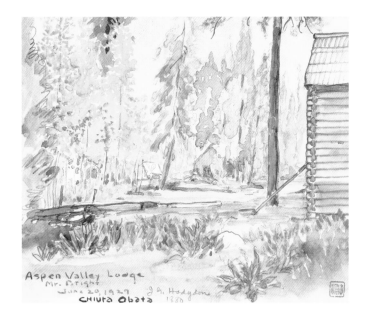

Interestingly, Tadeo Takamizawa, one of Japan's premier print publishers, was in San Francisco the following month. There he lectured in conjunction with an exhibition of paintings and ukiyo-e prints from his private collection, then on view at the California Palace of the Legion of Honor. It is not known if Obata met Takamizawa at that time. If such a meeting had taken place, it may have encouraged Obata to solicit Takamizawa Print Works to be the publisher of his portfolio when he arrived in Japan the next year. Takamizawa's reputation for excellence and his willingness to work with foreign artists were also likely factors in Obata's choice.[20]

On 6 March 1928 Obata's first one-person show in the United States opened at the East West Gallery of Fine Arts. Consisting of over one hundred works, many depicting the High Sierra, the exhibition received considerable, generally favorable, press coverage.[21] Perhaps Obata considered the event an accomplishment that would allow him to make good on his promise to his father to return home "when I am able to create, without fail, masterpieces that will be known to the world as those of Chiura Obata."[22] Tragically, Obata's father died on the final day of the exhibition.[23]

Obata subsequently began planning to go back to Japan. But due to previous commitments and the complexity and expense of making travel arrangements for himself, his wife, and their four young children, he was unable to undertake this trip until the fall. When he finally departed, Obata carried

Harden Flat, Sullivan's Cabin,
18 June 1927.
Pencil and watercolor on paper,
9 x 10⅞ in.
Annotated: *Hardin Flat/Sullivan's Cabin/June 18, 27*

Aspen Valley Lodge, Mr. Bright,
20 June 1927.
Pencil and watercolor on paper,
9 x 10⅞ in.
Annotated: *Aspen Valley Lodge/Mr. Bright/June 20, 1927/Chiura Obata/J G. Hodgdon/1880*

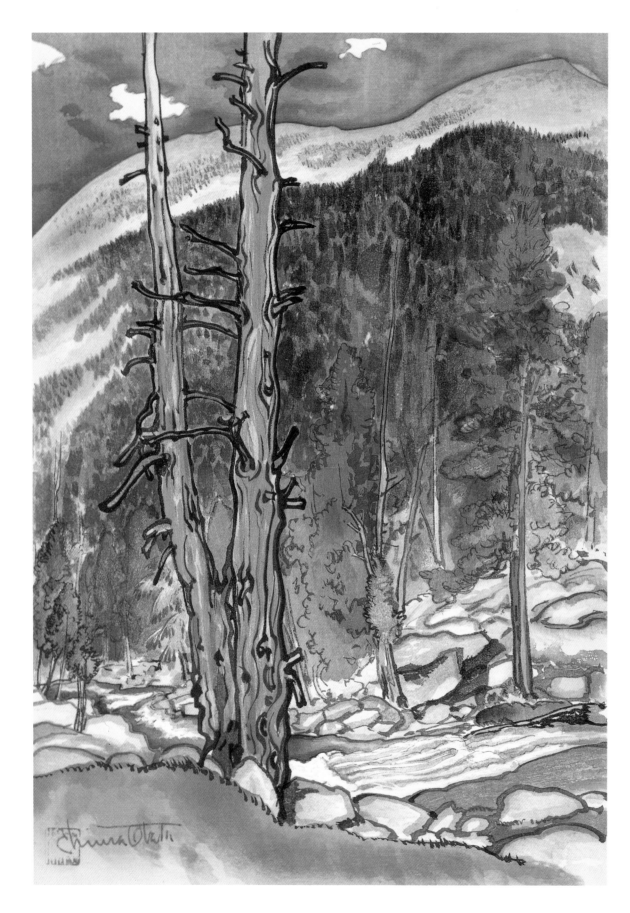

Upper Lyell Fork, near Lyell Glacier,
1930.
Color woodblock print, 15¾ x 11 in.

Tiny water drops that drip from the
glaciers in the High Sierra collect
themselves into a body of clear blue
crystalline water and dash down the
mountainside as the Lyell Fork.

with him his watercolors of the Sierra Nevada and other California scenes, for, as he later recounted:

> I thought it would be a good idea to make woodblock prints of them to give to people. The reason I thought of woodblock prints is that the most advanced woodblock printing is in Japan. . . . I wanted to preserve the art of my impressions of my travel in the High Sierra through the woodblock prints. It took a lot of effort. My hope was very difficult to achieve because it is difficult to make a woodblock print which expresses each touch of paint.[24]

Indeed, the color woodcut process, in which an image is created by carving multiple woodblocks with chisels and blades, cutting away all the parts that are not intended to be printed, is not conducive to conveying minute detail. In traditional Japanese practice, one or more craftsmen worked from a drawing created by a designer to prepare separate woodblocks for each area of color. First a key block, which carried the outlines for the composition, was completed to create a matrix from which subsequent blocks were carved for the additional colors. These were then printed with waterbase inks made from natural pigments, and usually the key block was laid last.

Although the printer might manipulate the inks, creating gradations in value and hue in the printing process, or add other materials (including mica) for embellishment, the resulting prints were characterized by large unmodulated areas of color and by a corresponding simplification of the subject. These were among the qualities that made Japanese woodblock prints so highly prized following their introduction to the West in the mid-nineteenth century. In contrast, Obata sought to emulate the precise details and subtle washes he had accomplished in his watercolors. Thus, despite the reinvigoration of printmaking in Japan in the early twentieth century by modifications that had been made to traditional ukiyo-e practices, Obata's woodcuts of the High Sierra posed new challenges to artist and publisher alike.

Early Japanese woodblock prints were initiated and overseen by the publisher, often with little participation from the artist after the drawing that served as a model had been submitted. But by the 1920s, the artist had assumed new responsibility. This was true for Obata, who commissioned Takamizawa to create a product to his own high expectations. Given the unusual demands of the project, however, it seems likely that the artist and publisher were both strongly committed to its realization in the manner Obata envisioned. For instance, in order to approximate the watercolors, scores of blocks were carved. They were often printed more than once, some many times. This process

Untitled (Lyell Fork), 1927.
Pencil on paper, 9 x 6 in.

necessitated the use of specially prepared paper, made by Fukui Sugiwara in northern Japan, that could withstand the repeated dampening that accompanied the applications of waterbase inks.

Obata described his first woodblock effort as a print of "a high mountain lake," with Johnson Peak in the background, almost certainly *Lake Basin in the High Sierra*. The choice was an apt one. The scene had received notice in Obata's San Francisco exhibition and was the subject of the large painting offered to and accepted by the emperor of Japan at the time of his coronation in 1928.[25] Surviving state proofs for *Lake Basin in the High Sierra*, numbering nearly 100, document the demands of translating this and other images from watercolors to woodblock prints. Each composition in the series required a similar effort, with some existing in as many as 160 states before they were completed. Perhaps the best indication of the complexity and magnitude of the project is that it occupied more than thirty-two carvers and forty printers for an eighteen-month period.

page 61

The carving and printing of *Lake Basin in the High Sierra* proved challenging, and Obata indicated that he was not pleased with the initial results. He recalled that

> The first time . . . the color looked like some place in Japan, not in the High Sierras. I thought this was wrong. So I called him [the carver] to a famous tofu restaurant called Sasa no Yuki in Negishi. I gave a lecture about the High Sierras. There is this kind of life over there, the pine trees look like such and such, different from the pine trees in Japan. There are big trees and boulders, mountains about 3,000 meters high. I told them [*sic*] many things. . . . The next time we had better results but I still wasn't satisfied. I called him one more time, and talked to him. The third time we spent a . . . lot of time, then we submitted it to the 81st Japanese Art exhibition contest.[26]

Obata reported that the print won first prize, a silver cup. The carver, Shizuka Baba, asked to keep the award because he was descended from a long line of woodblock carvers and had not yet earned such an honor.[27] Although Baba's inscription appears on proofs for *Lake Basin in the High Sierra*, the published print and the other prints in the series bear only the imprint of Obata and Takamizawa Print Works.

Little is known about either Obata's intentions in creating his print portfolio or how it was marketed. Print series depicting famous views certainly had a long history in Japan.[28] But Obata had made only one—quite simple— woodcut of a rabbit prior to embarking on this project and, despite his

*While standing at Death's Grave Pass,
I recalled many American Indian
legends and historical facts centered
on the imposing Tenaya Peak seen
in the distance.*

Death's Grave Pass and Tenaya Peak,
1930.
Color woodblock print, 11 x 15¾ in.

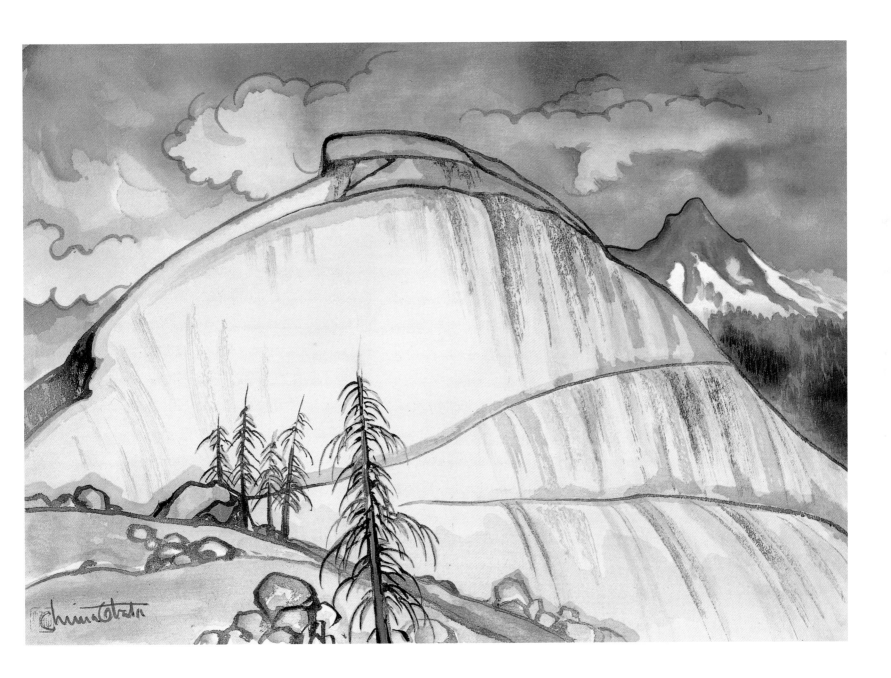

expressed desire to expand the series, made no subsequent prints of this kind.

The importance of the project to Obata is indicated in his wife's recollections: "We paid for the wood block prints by spending all our savings which we had taken to Japan. In order to return to San Francisco, we had to borrow 20,000 yen . . . with a promise to repay when [Obata] earned his salary from the University of California. We sent many payments and it was hard work to pay off that debt."[29]

Despite the financial burden Obata assumed, he maintained rigorous standards for the quality of each woodblock print. Reportedly, 400 impressions of each of the 35 compositions were made, with only the finest 100 selected for the portfolios. The 10,500 "less perfect" impressions were destroyed.[30] The surviving woodblock prints were packaged in sleeves bearing handprinted plates with the title and the artist's and publisher's names flanking a peacock with flowers.

Since he had commissioned the project and paid for at least some of its costs, Obata returned to the United States with probably many, if not all, of the portfolios. The West served as the major market for such endeavors at the time, and Obata made no mention of sales of the prints in Japan, although a number may have been offered as gifts.

Surprisingly few of the prints can be located in American collections. Even if Obata's limited financial resources prevented him from undertaking sales tours throughout the country (a practice successfully employed by other Japanese artists at the time), his commitment to the project and the attention it received suggest that the prints should be better represented in American—particularly West Coast—collections.[31]

Whatever the market may have been for Obata's *World Landscape Series*, the prints were publicized immediately on the artist's return to the United States and were the centerpiece of numerous exhibitions during the next two years. Even as Obata was en route to California, an exhibition was held at the Honolulu Academy of Arts, which opened on 31 October 1930. The woodblock prints were praised in the local press for their "decided innovations," and writers noted the "remarkable . . . technical skill demonstrated by the artist and . . . the peculiar watercolor effect obtained."[32] By 18 November, Obata's forty-fifth birthday, a preview of the portfolio was offered at Gyosei Hall in San Francisco. Again, the effort required to achieve these images was remarked on, including the observation in the *San Francisco Chronicle*: "An amount of sustained and painstaking labor almost inconceivable to the less patient Western mind has gone into the making of these ineffably colored prints."[33] Critics soon

Killed by white ants, a row of tamarack [lodgepole] pines stands calm and silent for several miles along the pass. Their mysterious deathly beauty greets those who pass by here.

Death's Grave Pass, 1930.
Color woodblock print, 11 x 15¾ in.

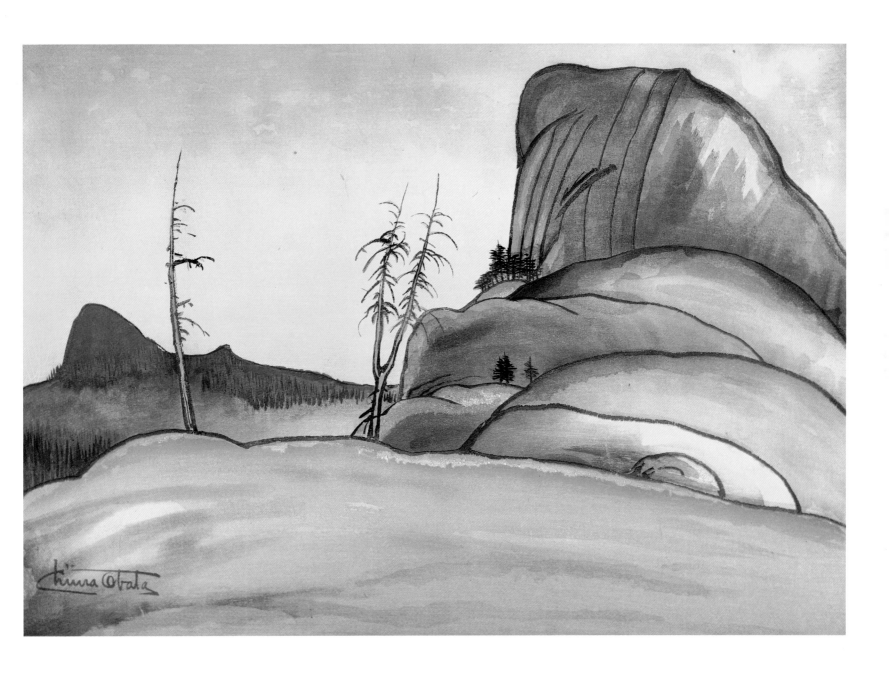

addressed the aesthetic significance of these works as well, describing Obata as "the famous Japanese artist who two years ago thrilled San Francisco with his original paintings of California; especially of magnificent spots in the 'High Sierras,'"and as "the first artist who has taken California subjects for genuine Japanese woodblocks."[34] The prints apparently found favor with Obata's peers as well; a newspaper clipping from an unidentified source, published about 30 November, describes the preview reception at the Catholic Hall as having "attracted the entire membership of the local art colony."[35] By 1 December Obata's woodblocks were on view at Haviland Hall on the University of California campus, accompanied by a brochure introduced by Perham Nahl. H. L. Dungan commented that "no such detailed work had ever been tried until Obata returned to Japan, the land of his birth, two years ago," and that "in addition to supervising the print making, Obata made 600 paintings during his two years' stay in Japan."[36]

Several more exhibitions in San Francisco followed, opening within days of one another. On New Year's Day 1931, Obata's woodblock prints were installed at the Courvoisier Gallery, and the next week a joint exhibition of his work and that of his father was mounted at the California Palace of the Legion of Honor in Lincoln Park. Predictably, press reaction was favorable and focused on the process used. Critics were also sensitive to Obata's perception of the California landscape, and, in dubbing him "a nature worshipper if there ever was one," one writer related that "he declared once that he gains new strength when tired by looking at the Big Trees. He knows how to render the melancholy beauty of Lake Mono, the majesty of Yosemite cliffs, the promise of life as evidenced by young redwoods growing above fallen giants."[37] In mid-February 1931 the *World Landscape Series*, along with five hundred of the progressive proofs demonstrating how the prints were developed, was exhibited at the San Francisco Art Association. The following month a display at Mills College also included the actual woodblocks, which are now lost.[38] By May, Obata's prints were featured at Stendahl Galleries in Los Angeles, concurrent with a visit by the Japanese emperor; later in the year they were shown at the Little Theatre in Santa Maria, in Southern California. Although the Yosemite prints were exhibited at the A. F. Marten Gallery in San Francisco in 1932, by that time Obata was contributing mostly newer work to gallery and museum exhibitions.

In the two years following their completion, however, the color woodblock prints from the Yosemite trip had been widely seen and admired throughout California. Chiura Obata's artistic accomplishment was perhaps best described as follows:

[T]o see our native beauty spots through the eyes of a foreign artist of high rank is to find new charm in our own land and a challenge to local artists who are content—so often—to repeat themselves in uninspired terms of unseeing eyes. So deeply has been stirred the soul of Obata in the course of his years of loving observation and painting here that inspiration is rekindled in those who hear him say, "I have lived in California for twenty-six years and I have fallen in love with the beauty of its scenery, I have dwelt happily among its beauties."[39]

From Watercolor to Woodblock

Although Chiura Obata was, by all accounts, a man of very modest resources, he chose to have progressive proofs made after each printing stage for several of the woodblock prints in the *World Landscape Series*, a costly and unusual practice. This decision may have been motivated by his interest in offering demonstrations of the carving and printing processes on his return to the United States.[1] As a result, the printmaking technique used in the preparation of the portfolio can be analyzed and studied.

Lake Basin in the High Sierra is one of the prints for which numerous proofs were prepared, and it is representative of the other prints in its development. According to Obata family records, a total of 107 impressions were made to complete this piece. Sadly, however, it is impossible to determine how many cherry blocks were used to create the final composition, as some blocks were reused for repeated applications of ink to build up color density. As well, a single block would have been carved in such a manner that it could be used for a number of different colors, as the composition allowed. Such invention was prompted by the high cost of the cherry wood employed.

It was common practice to begin the woodblock print by applying a pale buff base color (here in the sky, details of the snowpack, and lake), then to lay down the key block in gray.[2] This assured that the entire paper surface would receive ink, and that no areas would remain exposed. The key block carried the essential linear outlines of the composition and was cut to replicate the separations characteristic of the splayed tip of the artist's brush. Such detailed execution attests to the presence of skilled block carvers; the degree of craftsmanship exhibited would have been beyond the ability of an artist, such as Obata himself, who had not received lengthy training in this specialty.

The third step in creating the print was the application of a block inked in light gray that laid in the rocks in the background, middle ground, and foreground. A darker gray that enriched these areas followed, as the early blocks established areas of tone in disparate parts of the composition. Rock outcroppings in both the background and the foreground were developed in a pinkish tan in the fifth block, followed by details added in a pinkish brown, and

For just two months in the year the nameless lake nestling at the foot of Johnson Peak in the High Sierra comes to life from its wintery slumber. Rocks and five-needle pines along the shore cling to each other tightly. Countless streams run down the frozen mountainside, lending a sublime melody. Man's very soul and body seem to melt away into the singular silence and tranquility of the surrounding air.

Lake Basin in the High Sierra, 1930.
Color woodblock print, 11 x 15¾ in.

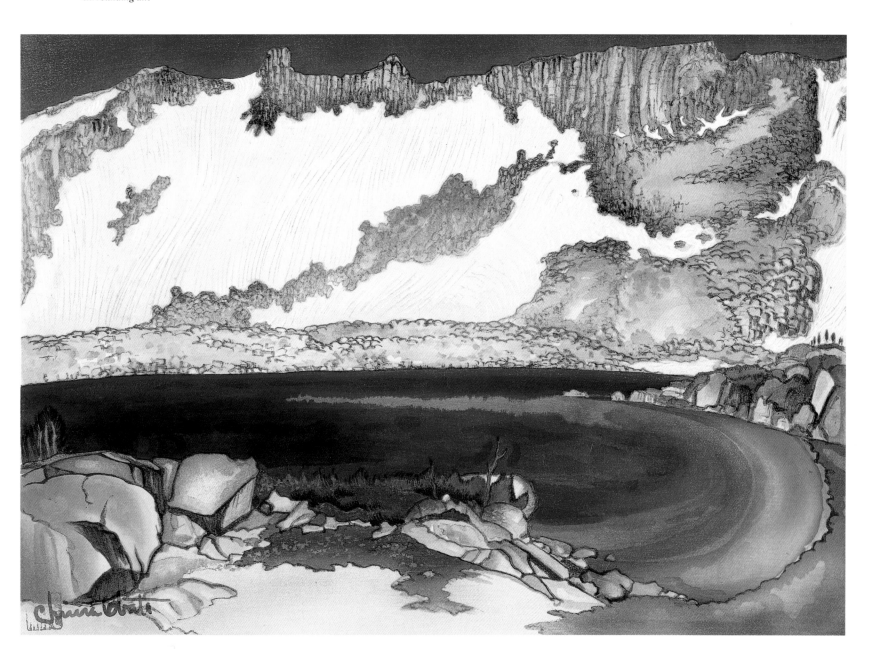

61

then a deepening of the sienna tones. In successive printings, brown shadows, some of which may have been made using an earlier block that had been reinked, were placed on the rock that juts into the basin at the lower right center, and on the large rock, branch, and shoreline at the right.

Obata, the carvers, and the printers appear to have concentrated on specific details within certain areas of the composition during the next stage. Refinements ranged from the printing of a yellow block for the bushes on the far shore (at center) to the addition of pink in the hills (at right) and stripes on the rock at the lower left. In the eighteenth state, pale blue appeared at the lower left corner, over which blue brushstrokes were superimposed. Subsequent changes, many of which were extremely subtle, focused on perfecting a single area, often with multiple applications of color. From states twenty-four through twenty-six, the rocks at the right became a center of attention and were developed in gray and purplish gray hues. Development of the lower shoreline followed. Next, green pigment derived from copper was printed, first on a rock at the left, then in the mountain on the right.

A transition from elaborating details to the overprinting of large areas with repeated blocks of color occurred as the print progressed. In the forty-third proof, green was placed at the lower right, to be overlaid with brown in the next printing; then the same block was inked with green and printed once again. Such multiple applications of color allowed the ink pigments, which were suspended in water, to achieve both density and translucency.[3] This process recurred in the printings that followed, with green ink, brushed across the grain of the cut woodblock to subdue its presence, applied to the lake area in the forty-seventh state. Such manipulations of ink on the block, with areas of pooled ink contrasted with relatively dry applications, or conscious inking either to enhance or to diminish the wood grain, were used frequently to create this image.

The lake surface was built up slowly, with a pale blue overprinting the green. Another layer of blue was then applied to enhance the grain of the block and to approximate the irregular edge of the wash on the watercolor model. Four subsequent printings in blue more clearly defined the original strokes of watercolor, and the reticulation that occurred as they dried; in addition, they deepened the color of the lake. Finally, a pale green was printed over the lake to add tone to the shoreline area, which received similar attention in the printings that followed.

Through the sixtieth stage significant details continued to be enhanced. For example, red was added to define the trunks of the diminutive pine trees at

State 10,
trial proof for *Lake Basin
in the High Sierra*, 1930.
Color woodblock print, 11 x 15¾ in.

State 25,
trial proof for *Lake Basin
in the High Sierra*, 1930.
Color woodblock print, 11 x 15¾ in.

State 36,
trial proof for *Lake Basin
in the High Sierra*, 1930.
Color woodblock print, 11 x 15¾ in.

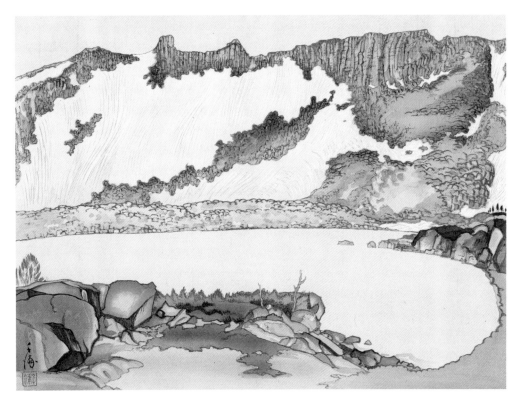

State 43,
trial proof for *Lake Basin
in the High Sierra*, 1930.
Color woodblock print, 11 x 15¾ in.

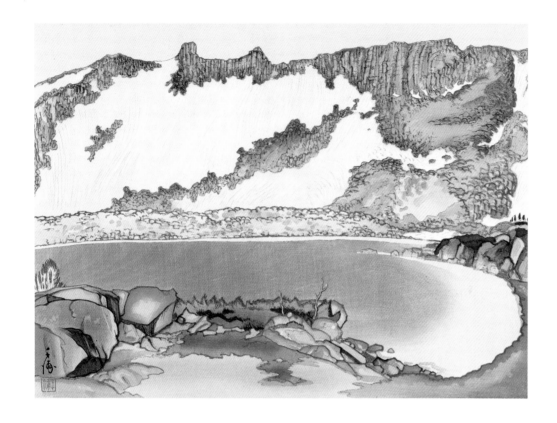

State 47,
trial proof for *Lake Basin
in the High Sierra*, 1930.
Color woodblock print, 11 x 15¾ in.

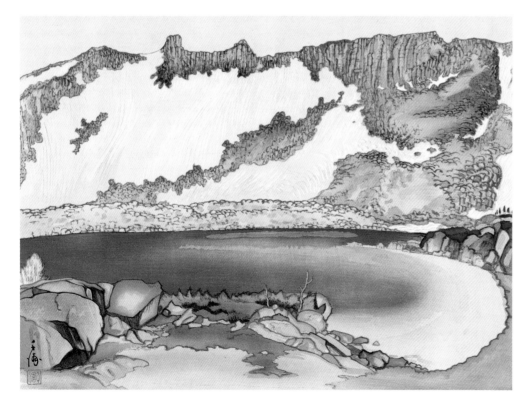

State 49,
trial proof for *Lake Basin
in the High Sierra*, 1930.
Color woodblock print, 11 x 15¾ in.

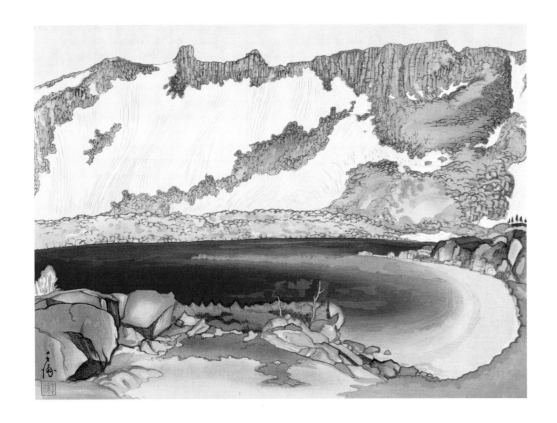

State 54,
trial proof for *Lake Basin
in the High Sierra*, 1930.
Color woodblock print, 11 x 15¾ in.

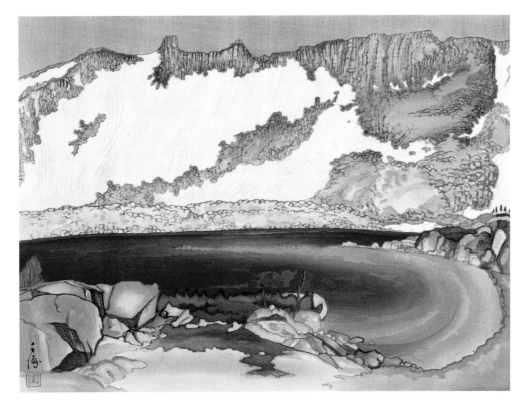

State 74,
trial proof for *Lake Basin
in the High Sierra*, 1930.
Color woodblock print, 11 x 15¾ in.

the left. Attention was then given to the foliage at the lower center, before purple was laid down over the sky in the seventy-fourth printing. As with the lake and other richly toned areas of the print, the sky was overprinted again and again to achieve the deep blue that appears in the final image.

In proof ninety-nine, the names Shizuka Baba and Manjuro appear, identifying the carver and printer respectively. These credits, which fail to acknowledge the host of artisans working under their direction, do not appear on any of the prints in the portfolio edition, and it is possible that this first print was created without the collaboration of Takamizawa.

Annotations on one of the proofs illustrate Obata's method of communication with the publisher. Typically, the artist would note desired changes on a sheet, then send it on. In the case of *Lake Basin in the High Sierra*, Obata requested that the title underneath the image, which entered on the seventy-ninth printing, be removed and that the sky be made bluer.

The arduous woodblock-making process just described was repeated tens of times as the Yosemite series was realized, with results that varied from the densely shrouded effect of *Evening at Carl Inn* to the luminosity of *Evening Glow at Lyell Fork, Tuolumne Meadows*. Where comparisons are available, the woodblock prints are strikingly similar to their prototypes. Obata realized his goal of utilizing color woodblock as a reproductive medium, and his prints include significantly more detail than do Hiroshi Yoshida's compositions, such as *El Capitan*, and other contemporary Japanese landscape prints.

page 124

page 113

page 48

JANICE T. DRIESBACH has been curator of art at the Crocker Art Museum since 1985. A graduate of Allegheny College, she received her M.A. degree in art history from the University of Iowa. She served as assistant curator for prints, photographs, and modern art at the Indiana Art Museum and as an exhibition coordinator for the Smithsonian Institution Traveling Exhibition Service and at The Oakland Museum. Among her publications are *German and Austrian Expressionism, 1900–1920* (1977); *Bountiful Harvest: 19th-Century California Still Life Painting* (1991); and "Landmarks of Early California Painting" (*California History* [Spring 1993]).

OBATA'S YOSEMITE: AN INTRODUCTION

1. Because Chiura Obata signed his name following the Western convention of placing the family name last, the other Japanese names in this book have been so styled.

OBATA OF THE THOUSAND BAYS

1. Unless otherwise noted, the biographical information presented in this essay is based on interviews by the author with Obata's granddaughter, Kimi Hill, and on papers in the Obata family collection.

2. Adoption of siblings was not unusual in Japan at the time.

3. See Chiura Obata, "How Painting Is Taught in Japan," *Argus* 3 (April 1928): 7.

4. Henry P. Bowie, *On the Laws of Japanese Painting: An Introduction to the Study of the Art of Japan* (San Francisco: Paul Elder and Company, 1911), 19–20.

5. Kumataro Ishida and Sanjin Shuyu, *Kitare, Nihonjin* (Tokyo, 1887), quoted in Yuji Ichioka, *The Issei: The World of the First-Generation Japanese Immigrants, 1885–1924* (New York: The Free Press, 1988), 11.

6. George Goldberg, *East Meets West: The Story of the Chinese and Japanese in California* (New York: Harcourt Brace Jovanovich, Inc., 1970), 43.

7. Ichioka, *The Issei*, 99–102.

8. Quoted in Goldberg, *East Meets West*, 33.

9. Obata enrolled at the Mark Hopkins Institute during his first year in San Francisco, but after witnessing a food fight, he concluded that the students were not sufficiently serious. Ironically, the institute at that time was reputed to have been more disciplined than ever in its history, with the exacting Arthur Mathews as director.

10. James H. Soong, Chiura Obata: *A California Journey*, exh. brochure (Oakland, Calif.: The Oakland Museum, 1977), 3–4.

11. Torao Miyagawa, *Modern Japanese Painting: An Art in Transition* (Tokyo: Kodansha International, 1967), 24. The nude had, however, long been a staple of *shunga*, a genre of erotic art intended for private consumption.

12. San Francisco Museum of Art Papers, 1921–37, file marked "1922—East West Art Society," Archives of the Anne Bremer Memorial Library, San Francisco Art Institute.

13. San Francisco Museum of Art, *East West Art Society Second Exhibition*, exh.

brochure (San Francisco, 1922).

14. J. Nilsen Laurvik to Mrs. C. H. Obata, 8 March 1922, Obata family papers.

15. These sketches are currently in the Obata family collection.

16. Chiura Obata, interview, 1967, Japanese American Research Project, University of California at Los Angeles. Translation by Kimi Hill and Teiko Sano.

17. See David Robertson, *West of Eden: A History of the Art and Literature of Yosemite* (Yosemite National Park, Calif.: Yosemite Natural History Association; Berkeley: Wilderness Press, 1984), 109.

18. William Keith, quoted in Alfred C. Harrison, Jr., "Yosemite Painting: The Golden Age, 1850–1930," *Art of California* 4 (January 1991): 16.

19. Quoted in Harrison, "Yosemite Painting," 16.

20. John Muir, quoted in Charlotte E. Mauk, ed., *Yosemite and the Sierra Nevada* (Cambridge, Mass.: Riverside Press, 1948), 15.

21. Eleanor Morris, "The Lighthouse," *Daily Californian* (Berkeley), [ca. September 1931].

22. Michael Sullivan, *The Arts of China*, 2d rev. ed. (Berkeley: University of California Press, 1977), 164.

23. Obata, quoted in Eleanor Morris, *Daily Californian*, 5 February 1934.

24. Muir, quoted in Mauk, *Yosemite*, 114.

25. Obata, quoted in "Critic in Praise of Japanese Man," *Japanese American News*, 1 March 1928.

26. Arthur Millier, *Los Angeles Times*, 11 December 1938, quoted in Janet Blake Dominik and Ruth Lilly Westphal, *American Scene Painting: California, 1930s and 1940s* (Irvine, Calif.: Westphal Publishing, 1991), 61.

27. In the late 1920s and early 1930s, the East West Gallery of Fine Arts regularly showed the work of modernists, which it alternated with Asian art, both contemporary and ancient; in the late 1920s the gallery featured work by Matisse, Picasso, Vlaminck, and Gauguin. The Courvoisier Gallery also emphasized contemporary modernists, both Asian and Western; in 1928 it showed work by Picasso, Charles Sheeler, Yun Gee, Robert Howard, Adaline Kent, and Dorr Bothwell.

28. For a discussion of Asian influences on contemporary modernist art, see

Jehanne Bietry-Salinger, "Modern Art, Ever Living," *Argus* 2 (February 1928): 2.

29. Ann Sommer, "Two Exhibitions Here Will Show Subtle Influence of Japanese on Creative Art," *San Francisco News*, 14 May 1932.

30. The phrase "Berkeley School" was first used by the critic Alfred Frankenstein in a review in 1937; see *San Francisco Chronicle*, 7 November 1937.

31. Dominik and Westphal, *American Scene Painting*, 80.

32. See Gene Hailey, "The Permanence of Japanese Pigments," *Argus* 3 (May 1928): 11.

33. Rumors of Japanese American conspiracy and sabotage plots were rampant in the months following Pearl Harbor. One accused California farmers of planting their tomatoes in the shape of an arrow to guide enemy bombers. Rudolph S. Rauch, "Internment," *Constitution* 4 (Winter 1992): 35.

34. Among the more substantial supporters of Obata's art schools was Grace McCann Morley, director of the San Francisco Museum of Art. Morley also solicited work from the camps to include in the museum's annual exhibitions.

35. H. L. Dungan, "Five Hundred Students in Art School," *Oakland Tribune*, 12 July 1942. Several exhibitions have been organized on internment camp art; see Karin Higa et al., *The View from Within: Japanese American Art from the Internment Camps, 1942–1945*, exh. cat. (Los Angeles: Japanese American National Museum, 1992); and Deborah Gesensway and Mindy Roseman, *Beyond Words: Images from America's Concentration Camps* (Ithaca, N.Y.: Cornell University Press, 1987).

36. Obata, quoted in Eleanor Morris, *Daily Californian*, 5 February 1934.

37. Obata, quoted in "Chiura Obata," *California Art Research*, 1st series (San Francisco: WPA Federal Art Project, 1937), 148.

OBATA'S VISION OF YOSEMITE

1. Although the watercolors that were models for Obata's color woodblock prints are dated to the summer of 1927, it is uncertain if the dates refer to when they were made or when Obata encountered the scene described. Since these sheets are identical in dimensions to the woodblocks, which were a standard Japanese print size, it appears they were conceived as models for translation into color woodblock images. Very similar works seen in photographs of Obata's spring 1928 exhibition suggest that the artist had

conceptualized the project prior to his father's death in late March.

2. Hiroshi Yoshida previously had made prints for the famed publisher Shōzaburō Watanabe, whose shop had suffered severe damage in the 1923 Tokyo earthquake. After his return from abroad, Yoshida began to publish his prints independently. See Helen Merritt, *Modern Japanese Woodblock Prints: The Early Years* (Honolulu: University of Hawaii Press, 1990), 75–77, and Tadeo Ogura et al., *The Complete Woodblock Prints of Yoshida Hiroshi* (Abe Publishing Co.).

3. A photograph of Kazue Yamagishi demonstrating woodblock carving with Nahl, Obata, and several University of California students looking on was published in the *San Francisco Chronicle* on 15 February 1927. Yamagishi had mounted a concurrent exhibition of his woodblock prints, which were made both from original designs and after compositions by other artists, at the university's Haviland Hall. He installed his woodblock prints and the images from which they were made one beside the other, foreshadowing Obata's installation of his prints at the California Palace of the Legion of Honor in San Francisco four years later.

4. Although Obata's recollections indicate that he joined the University of California faculty in 1932, former students, among them May Blos, undated correspondence with author, and Gene Kloss, letter to author, 20 November 1992, recall his teaching classes in 1923 and 1924.

5. Monica Haley, "Worth Ryder: Artist and Art Educator," unpublished manuscript, Bancroft Library, University of California at Berkeley, n.p.

6. Haley, "Worth Ryder."

7. From a card completed by Ryder in 1915 on file at the California State Library, Sacramento. These lithographs appear to be quite rare; one is listed in the holdings of the Achenbach Foundation for Graphic Arts, The Fine Arts Museums of San Francisco, and another was published in *Fifty Years of California Prints, 1900–1950*, exh. brochure (Santa Rosa, Calif.: Annex Gallery, 1984).

8. Miriam Dungan Cross, "A Delightful Day with the Achenbach Foundation Donors," *Oakland Tribune*, 19 June 1955.

9. Cross, "A Delightful Day."

10. Chiura Obata, oral history, Japanese American Research Project, University of

California at Los Angeles, 1967.

11. "Obata Gets Spirit of California in His Prints: Sierra Trip with Obata Is Told by John [sic] Howard, Important Local Artist," *Art and Artists* 2 (January 1931): 1.

12. "Obata Gets Spirit of California," 1.

13. Chiura Obata, 20 July 1927, White Wolf.

14. Stanford E. Demars, *The Tourist in Yosemite, 1855–1985* (Salt Lake City: University of Utah Press, 1991), 106–8, and Carl P. Russell, "Opening New Yosemite Wonders," *Yosemite Nature Notes* 4 (April 1925): 25–26.

15. Chiura Obata, 4 July 1927, White Wolf.

16. Chiura Obata, 16 July 1927, Tuolumne Meadows.

17. Chiura Obata, 26 July 1927.

18. Chiura Obata, 30 July 1927, Tuolumne Meadows.

19. H. L. Dungan, "Artists and Their Work," *Oakland Tribune*, 11 September 1927.

20. Gene Hailey, "Art News of the Week," *San Francisco Chronicle*, 9 October 1927; notes accompanying Tadeo Takamizawa, "Japanese Art: The Ukiyo-ye Genre," *Argus* 2 (November 1927); and Helen Merritt, telephone conversation with author.

21. Among the periodicals in which the exhibition was reviewed were the *Argus*, *Japanese American News*, *Oakland Tribune*, *San Francisco Chronicle*, *San Francisco Examiner*, and *San Jose Mercury*.

22. Chiura Obata, "In Praise of Nature," Obata family papers.

23. Chiura Obata, oral history, Japanese American Research Project.

24. Chiura Obata, oral history, Japanese American Research Project.

25. *Oakland Tribune*, 11 March 1928, and Gene Hailey, ed., *California Art Research* 20, no. 2 (San Francisco: Works Progress Administration, 1937), 139.

26. Chiura Obata, oral history, Japanese American Research Project.

27. Chiura Obata, oral history, Japanese American Research Project.

28. *The Thirty-six Views of Fuji* by Hokusai and the subsequent series of *The Tokaido Road* of 1833–34 by Hiroshige are among notable examples.

29. Haruko Obata, oral history, 6 April 1986.

30. H. L. Dungan, "Wood Block Prints of San Francisco Artist Exhibited at U. of C." *Oakland Tribune*, 11 December 1930.

31. A complete set of the prints and some individual sheets are in the collection of the Obata family. In 1955 the Achenbach Foundation for Graphic Arts purchased from Gump's in San Francisco a complete set, which reportedly had been acquired in Japan. An incomplete set is in the collection of the University of California at Berkeley. However, there are no examples in other San Francisco Bay Area collections, among them Mills College, The Oakland Museum, the San Francisco Museum of Modern Art, and Stanford University. Several private collectors have acquired one or more prints from the Obata family, or perhaps from sources in Japan. However, given that 100 sets were printed, a sizable number—nearly 3,100—of the woodblock prints remains unaccounted for, raising questions as to how many portfolios were brought back to the United States and how they might have been marketed.

32. "Local Artist's Exhibit at Academy Most Impressive; Obata's Prints," *Honolulu Advertiser*, 2 November 1930.

33. "Woodblocks by Chiura Obata Shown in Preview," *San Francisco Chronicle*, 23 November 1930.

34. "Obata Back with Woodblocks of California Views," *Art and Artists* 1 (November 1930): 2.

35. Newspaper clipping, Obata family papers.

36. Dungan, "Wood Block Prints of San Francisco Artist."

37. Nadia Lavrova, "Japanese Wood-Block Prints on View," *San Francisco Examiner*, 4 January 1931.

38. "Japanese Woodblock Prints Shown at Mills College," *Oakland Tribune*, 5 March 1931. Although the article alludes to the exhibition of the woodblocks, members of Obata's family believe that the blocks remained in Japan and were most likely destroyed during World War II.

39. *Saturday Night* (Los Angeles), 23 May 1931.

FROM WATERCOLOR TO WOODBLOCK

1. Hidekatsu Takada, Takada Fine Arts, interview with author, 5 November 1992.

2. Hidekatsu Takada, interview.

3. Hidekatsu Takada, interview.

Pack Mules, n.d.
Sumi on postcard, 5 ½ x 3 ¼ in.

*These pack mules carry everything all
the way up here.*

PERSONAL ACCOUNTS
OF THE HIGH SIERRA TRIP

[Obata kept in close contact with his family in San Francisco while he was in Yosemite and the Sierra through letters written to his wife, Haruko Obata. A selection of these letters, published here for the first time, provides invaluable information about the man and his reactions to the new scenery he encountered.

Unlike letters written in English, in which the salutation and date appear at the beginning, letters in Japanese typically place these elements at the end. These translations adhere to the Japanese format but also repeat the date and give the site at which the letter was written in square brackets at the beginning, so that the letters can function as an easy-to-follow record of Obata's trip.]

Letters from Yosemite, 1927

Groveland, 16 June 1927.
Sumi on postcard, 3¼ x 5½ in.

Today at 12:00 we arrived at Big Oak Flat Road, gateway to Yosemite. Now we are about to leave Groveland, the last station of the coach, and we'll enter into the true High Sierra. The altitude is about 4,000 feet, the temperature about 92–93 degrees. We have a big load for a small car and the passers-by laugh. Our trip is unhurried. We take our time and sketch.
June 16, 2 P.M. Chiura

Buck Meadow

六月十七日朝
リョウ
キセ
静かな旅
とき味のとも
とまる家
じ店白い家
何の旅友ダチ
とろよう...
ジョージ
George
Bartlett

味深き話
やとる
宿

Buck Meadow, 17 June 1927.
Sumi on postcard, 3¼ x 5½ in.

Last night we stayed here.
I met Mr. Ryder's old friend named
George Bartlett. Before going to sleep
we listened to his interesting stories.
morning, June 17 Chiura

[JUNE 20, 1927, NEAR WHITE WOLF]

We camped at a place called Buck Meadows, and after we left I realized I had forgotten my sweater. I was able to ask someone to look for it, but it was not found. Please buy another one made out of strong wool and send it to me.

We left Carl Inn at 9:00 this morning. We have brought with us about half the baggage into the mountains.

Carl Inn is located at 4,500 feet. It stands at the intersection of the road that leads to Hetch Hetchy Valley on the Tuolumne River and the Big Oak Flat Road, which we have climbed from Oakdale and leads to Tioga Pass.

This morning we climbed the Tioga Road, which runs across the upper part of Yosemite Park. Hike in the mountains for four or five miles and you can see giant trees of cedar, yellow pine, or the sugar pine, which is said to bear cones every seven years. Across the valley is the Tuolumne River. On the Middle Fork are towering mountains and forests of big trees. Six miles away is the Stanislaus County national park. After wandering for one or two miles in the national forest, we reached Aspen Meadow where aspen trees are growing. Here it is about 8,000 feet above sea level.

Copper-colored sugar pines, dark black firs, rolling blue ridges. Among the snow in the towering black forest the snow plant stands aflame.

As we climb a steep hill, the mountain path becomes a little narrow with many giant trees and large rocks that might please a mountain lion.

page 124

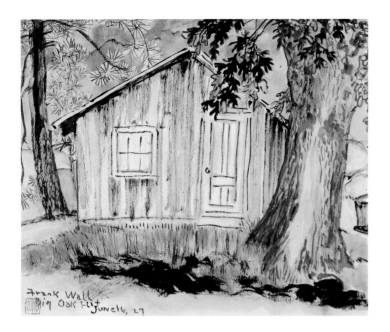 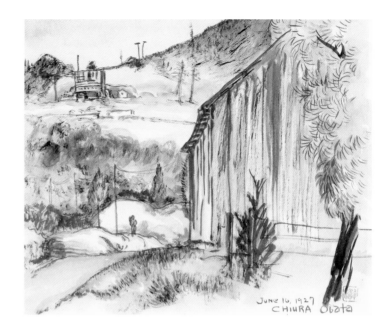

We have come to the upper Middle Fork of the Tuolumne River. We are talking about setting up a base camp for a while at the second bridge of the upper river, and walking to Harden Lake and to Yosemite. The altitude is about 9,500 feet. There is much snow left, but the temperature during the daytime is very pleasant at about 90 degrees. However, from 5:00 and through the night, especially toward dawn, it is pretty cold. Since the blanket I brought is thin, I sleep with some canvas and wear a heavy shirt and wool socks, but sometimes it is still cold. Just recently ten men were working to remove snow from Tioga Pass a little farther away from here. Up until now they have been working around Porcupine Flat, where we are heading. Thus, the road has just been opened. Being cautious, we will first check out a place about fifteen or sixteen miles away and then bring our baggage along like ants carrying things. This takes some work but so far we have not had a flat tire.

Mr. Ryder's driving is very careful and we have not had any trouble with the car. We are driving with two beds, fourteen boxes of food, painting materials, fishing gear, two suitcases, a tent, a large saw, a large axe, a big shovel, and a big bucket of water in case of emergency. Most people smile at us, thinking we are going to the mountains to find gold.

Last evening we got some meat and I cooked sukiyaki with *koyadofu* [dried tofu], onion, *tsushin* [noodles], and some of the same tender grass that was growing in Alma. It was quite delicious. The army pot, which I borrowed from Sato-kun [a friend; "-kun" is added to a name when referring to or addressing a friend], is very good. I sometimes drink a cup of sake at dinner,

Frank Wall, Big Oak Flat,
16 June 1927.
Sumi and watercolor on paper,
9 x 10⅞ in.
Annotated: *Frank Wall/Big Oak Flat/ June 16, 27*

Untitled, 16 June 1927.
Sumi and watercolor on paper,
9 x 10⅞ in.
Annotated: *June 16, 1927/Chiura Obata*

and now there is not much left in the half-gallon bottle. In the cold evenings it helps me stay warm, so give one gallon to Howard-kun to bring before he leaves.

Since Mr. Ryder is driving the car he cannot watch the scenery and he gets tired, so he has not done any sketches. But as for me, every place we go amazes and interests me, so I have been doing nothing but sketching.

In the Middle Fork River, where we will return tomorrow, we could see trout even from the moving car. So we should be able to catch a lot of them. Tomorrow both of us will fish and we'll have trout for dinner.

I sent cards to everyone: Shunshuro, Hibi, and Yoshizato [friends in San Francisco]. All are sketches, so I'd like them to be kept for references. I hope Ojiisan [Haruko's father], Kimio, Fujiko, Gyo, and Yuri [Obata's children] are well. San Francisco's weather might not be good, so take good care of yourself.

As for me, you needn't worry about anything. The other day when we were at Buck Meadows we went to see the north branch of the Tuolumne River. Our guide was George Bartlett, a U.C. alumnus. Mr. Ryder said they killed a six-foot-long rattlesnake, although I didn't see it, as I was sketching. I was told that around here, where the altitude is more than 5,000 feet, it is too cold for snakes to appear until August.

The air in the high mountains is so clean, and the trees, grass, birds, and flowers are fascinating beyond description. There are birds much like the canary. Beautiful flowers bloom in a stream of icy water. I only feel full of gratitude. I want to bring you and our friends here, and I will.

This morning I woke up at around 2:00 and I saw the moon shining in the woods, on the river, and in the meadow. It evoked in me the days of the gods.

I feel sleepy now, so I'll go to bed.
Sayonara.

June 20, night Chiura

to Haru-dono ["-dono" is a term of respect added to a person's name]

Please show this to everyone.
The address for the sweater:
 c/o Worth Ryder
 P.O. Box 61 Oakdale, Cal.

Pine and Paintbrush, 18 June 1927.
Sumi and watercolor on postcard,
5½ x 3¼ in.

We finally arrived here today at noon. We're planning to stay for two to three days. Beneath this large pine tree are scarlet flowers called paintbrush. The color of the tree is very good. This address is fine for letters. We often have messages from the mountain.
P.M. June 18 Chiura

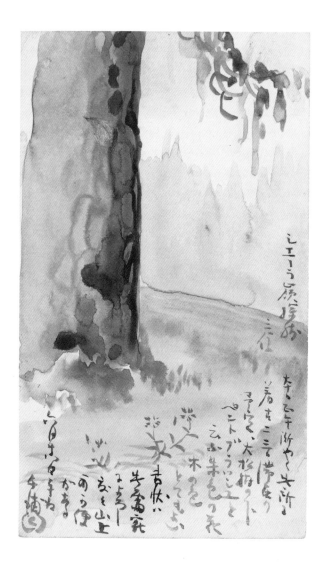

I received your letters of June 21 and June 22 (about the park) on Sunday, the 26th, from a mountain climber who was on his way from Aspen Valley.

Mr. Ryder had said that we were certain to have a storm here in the high-altitude area on June 25.

On Friday, after I returned from trout fishing in the nearby river, I found two big women had driven into our camp.

They were from Fresno. The one who looked like she weighed more than two hundred pounds was the younger sister who had worked as a cook for Mr. Ryder when he had a hotel in the King's River Canyon. She is quite cheerful and likes the mountains so much that she enticed her elder sister, a doctor's wife, to come all the way out here. Since she was good at cooking, especially mountain dishes, she prepared a feast, which we all enjoyed very much.

The next morning she prepared plenty of lunch for us, and at 8:30 we left to explore Porcupine Flat, which I had mentioned before, about ten miles away. After leaving White Wolf Meadow we came to a place called Dark Hole. The tall woods are dark even in the daytime. Three or four feet of snow still remained. A large deer watched our group suspiciously.

Past the Dark Hole the trail became very steep, and after taking a long detour, a magnificent view opened up: old pines were shooting up to the sky, the far summit of Starr King was in the distance, on the snowcapped mountains the great forests made several layers of blue lines like *suso moyo* [hem design]. As I breathed the air, standing on the pass gazing at the view, I felt keenly that the education of children was not in school but in letting them know great nature such as this.

We climbed and climbed a slope of more than 20 degrees and reached Porcupine Flat at 11:30. The altitude was 9,000 feet. Great silver fir and pine wound their roots around the unusual, interesting rocks left behind by the glacier's erosion. They stand even after having experienced hundreds of years of hardship.

The young grass grows in Porcupine Meadow with the help of the dewdrops from their leaves and each drop of pure water to their roots. The remaining pure water flows quietly, becoming a creek in the meadow. Lively brook trout grow there. I tried my fishing pole for a half hour before lunch and caught twenty-five trout of seven to eight inches. We broiled them on the fire and they made a delicious addition to our lunch. After lunch I sat on the highest rock and started to sketch. The direct sunlight can burn the skin, but I also felt the chill of the wind that brushes the snow under the trees in the high mountains.

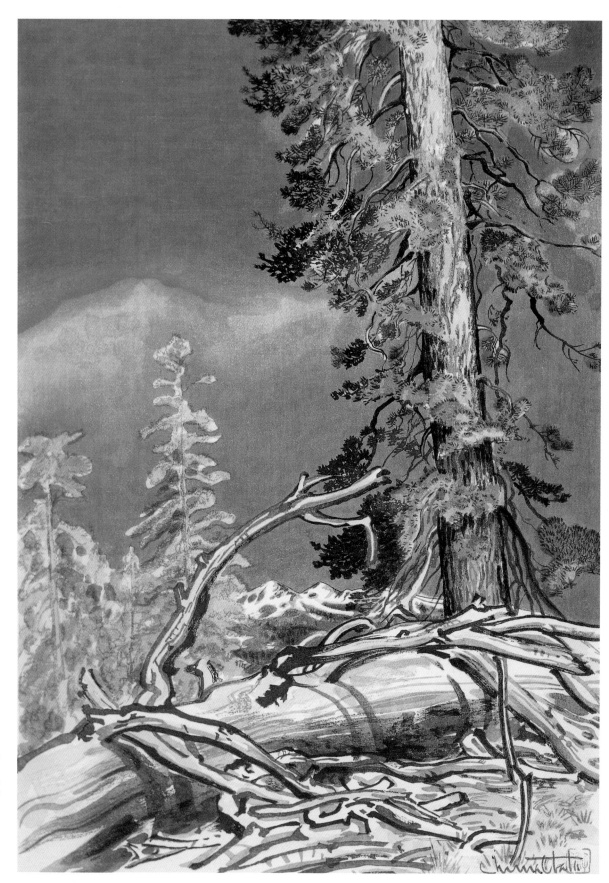

Life and Death, Porcupine Flat, 1930.
Color woodblock print, 15¾ x 11 in.

*In the burning heat of the summer day,
against the deep blue skies, stands a
towering pine tree, brimming with life.
At the foot of the pine tree lies another
tree, dead and white.*

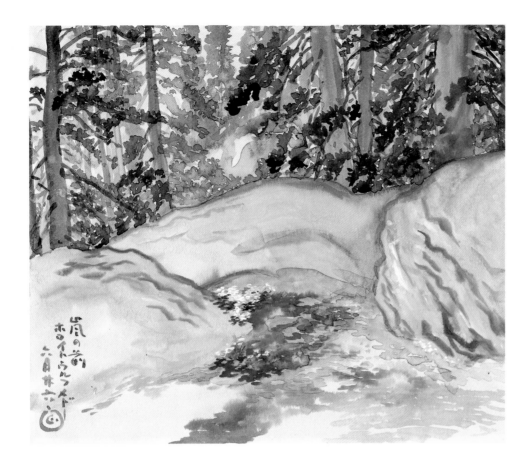

Before the Storm, White Wolf Meadow, 26 June 1927.
Sumi and watercolor on paper,
9 x 10⅞ in.

Untitled (Columbine), 1927.
Sumi and watercolor on paper,
15¾ x 11 in.

We selected the spot where we will move our luggage little by little, then we headed back. It was 3 P.M. Again we stuffed ourselves with the food the cooking teacher from Fresno High School had prepared for us. I picked up a brush to paint my impressions while listening to everyone's conversation by the fire.

Around 9:00 everyone became sleepy. We went to bed and gazed up at the branches and the stars through the trees.

Since the women guests were leaving early on the 25th, Saturday, we got up at 4:30, ate, and then left at about 6:00.

I return now to [the storm mentioned on] page one. White clouds appeared in the clear sky from the direction of Yosemite Valley. Ryder said, "See now. Storm coming." We collected some wood, just in case, and made preparations for the rain. At 3:00 the sky darkened, the clouds moved fast, and it started to rain. I was sketching the flowers blooming in between the rocks, but the rain made me run back to camp.

We finished supper at 5:00 and went to bed by 6:30. On June 26th (Sunday) at 2:00 or 3:00 I was awakened by a light outside the tent. Someone

was standing by the tent and Mr. Ryder was talking to him. It appeared that an aunt had died, and this man wanted to inform someone who was supposed to be camping around here. He said he came from Modesto and asked if we knew him. After learning that we didn't know, he disappeared in the rain together with the sound and light of his car. Mr. Ryder grumbled, "Dumb fool!" When I had awakened I wondered if the fire had gotten started, but soon I fell back to sleep. Mr. Ryder, after that, could not go back to sleep and was tossing about. I also slept in until 9:00.

I quickly finished breakfast and went to the south meadow where the skunk cabbage grows beautifully among the young grass. I was absorbed in sketching blue skunk cabbage and pale red shooting stars for three or four hours until Mr. Ryder called me from the trees saying, "Lunch is ready."

I went back and found your letter. I imagine it is foggy in San Francisco. Take good care of yourself. I have found a medicine here that is very effective for hemorrhoids so I will bring it back as a present. Tell this to Shunshuro-kun. What a misfortune Nishikata-kun [another friend in San Francisco] had! Having been nearly killed, he must have a large wound. Visit him and bring him something good. It might be called bad luck had he been hit by a car or something like that, but nowadays what a thing for a Japanese to do to another Japanese! If they came to the mountains and knew great nature they would appreciate and be grateful for life in everything and would not do such a foolish thing as that. Anyway, I feel sorry for him. Again, do go visit him.

The sweater must have arrived, so tomorrow I'll go get it in Aspen Valley, eleven miles away.

Emerald green 2 tubes
Chinese white big tube
Prussian blue 1 tube
Please ask Hibi-kun to send them right away. If Mr. Robert Howard is coming soon, you can ask him to bring them.

A quarter to ten P.M., 26th
I slept a lot this morning
So, I've written this much Chiura

To Haruko-dono

Divide the flowers. Will send them to Eiko next time.
Gillette razor—one dozen
To everyone—taste the mountain trout

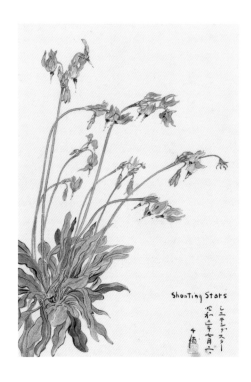

Shooting Stars, 2 July 1927.
Sumi and watercolor on paper,
15¾ x 11 in.
Annotated: *Shooting Stars*

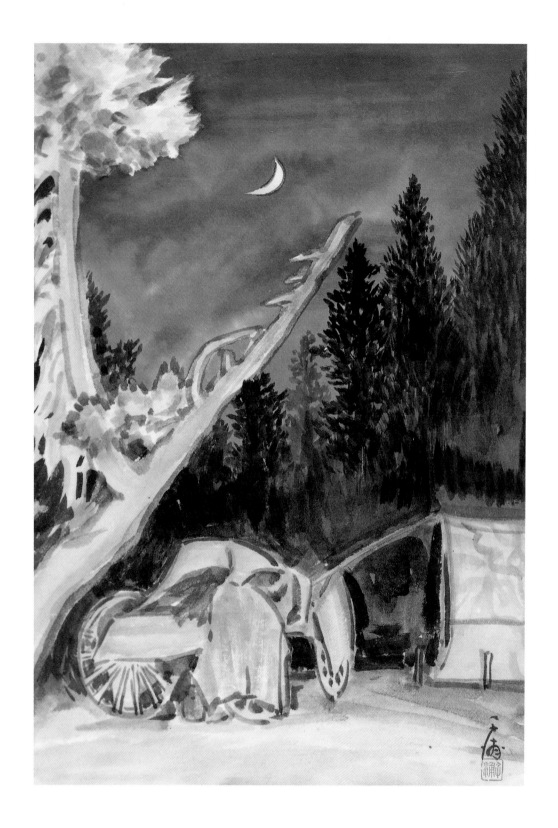

Untitled (Camp), 1927.
Sumi and watercolor on paper,
15¾ x 11 in.

Last night there was a heavy frost. It was so cold that the towels and salad oil became hard. But as soon as the sun shone, it warmed up and was very pleasant.

I picked some wildflowers by the rocks and under the trees around camp and I'm sending them to the children. Tell them not to spoil them. I was very sorry to pick them. Each grass and each flower had long persevered under more than ten feet of snow until, at last, in the spring they had grown into flowers. But I will send them since I wanted to show them to you.

[JUNE 29, 1927, WHITE WOLF]
Sierra Trip, Letter 7

On June 28 we left at 9:00 to explore Lukens Lake. We packed a lunch and some pine grubs for trout fishing. For about two miles we walked along the Middle Fork of the Tuolumne River. We tried to find the way with the map in our hands. After losing our way on an obscure trail several times, we finally climbed through a snow-covered pass and found the lake at 11:30.

It is not a large lake but to the north a glacial dome stands surrounded on three sides by silver firs and great five-needle pines. Its perimeter is about one mile.

We climbed onto a fallen tree and tried to fish with a spinner and grubs. Perhaps because the water level was high there was no response, and the beautiful light of the spinner cutting the deep blue water was in vain. We did see two eastern brook trout of about three pounds dead on the shore.

We made a fire, heated some tea, and had lunch. The lakeshore in the mountains was tranquil and silent. Looking up, we saw white clouds floating in the sky. They were rain clouds that looked like cotton. We remembered that we had left our bedding hanging out to dry at camp, so we left the lake. As we walked along the Tuolumne River, we continued to fish and we caught about fifty fish.

Upon arriving at camp we found Tim Sullivan, whom I had mentioned before. He has been living in these mountains for more than fifty years, and now he goes around the camps as a ranger of the National Forest and the National Park. He had come on his wagon pulled by donkeys and had already set up his tent by our camp. He greeted us by saying, "Steak dinner tonight."

At night I sketched Mr. Sullivan by the campfire. We sat around the fire and listened to all of his stories, which you would never hear in the cities.

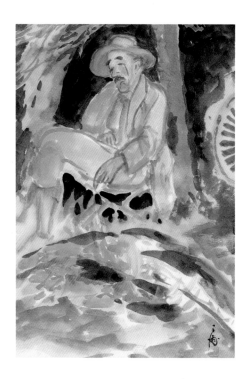

Untitled (Tim Sullivan by the Campfire), 1927.
Sumi and watercolor on paper,
15¾ x 11 in.

June 29 Got up at 5:15

Breakfast
3 cups of coffee
6 fried trout
6 pieces of flapjack
orange

Since the weather became clear I took out my Japanese paints and prepared a silk and various colors. I was short of paint dishes so I washed out the cans of the canned food. I painted until 11:30.

Lunch

I made sukiyaki with some of the ribsteak that we had brought back from Aspen Valley the day before yesterday along with *koyadofu*, onion, and cabbage.

After lunch I started sketching the surrounding woods. I worked hard until 5:30. The sunlight was very strong, so the gelatin [used to prepare the painting surface] hardened. This gave me a hard time. I gathered some twigs and made a fire to warm the paint. When I had almost finished painting, Ryder-kun shouted, "Dinner is ready."

Dinner
roast beef (cooked in a Dutch oven)
roast potato
cocoa
peach pie

As you can see, it was a real feast. Usually, though, we do not eat as much meat as today.

Send my letter, the whole prospectus, and five to six sheets to Tomihiro Seiichi-kun. You will find the census of Portland from Abe-san [two friends].

Letters arrive twice a week in Aspen Valley, eleven miles away. The sweater has not arrived yet, but it is not too cold. There are no rattlesnakes because it is too cold, so you don't need to worry.

I am so busy I cannot write a diary or journal. My letters replace a diary so please keep them.

How is Nishikata-kun? How is his condition? I asked you to visit him in my previous letter.

How is everyone? I have collected a lot of flowers and I'll send them at the next chance. Tell Gyo not to lose them. I wrote this by the campfire so you will understand if it is not clear.

Evening June 29 Chiura

To Haru-dono

The Lovely Moon Is Gone,
1 July 1927.
Sumi and watercolor on postcard,
5½ x 3¼ in.

Gyo-chan—The lovely moon is gone.
It went to bed early to sleep, grow big,
and shine more.

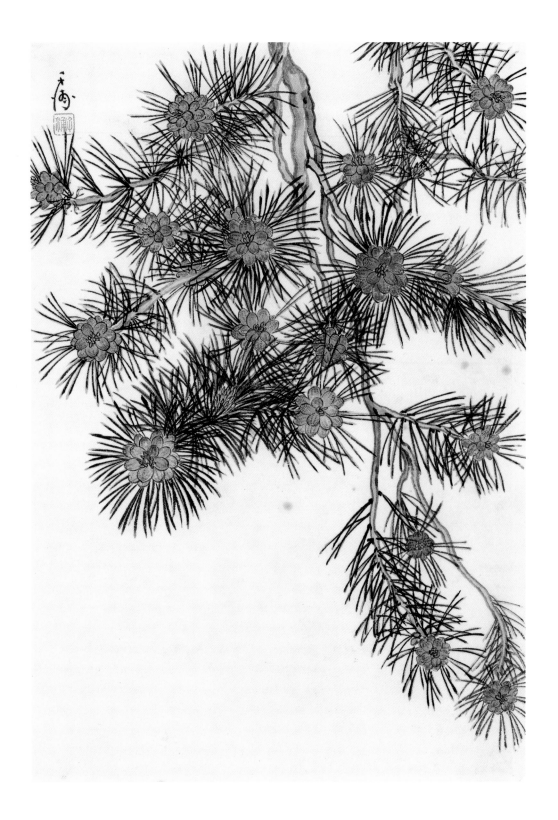

Untitled (Lodgepole Pine), 1927.
Sumi and watercolor on paper,
15¾ x 11 in.

Sierra Trip, Letter 8

Yesterday and today I cleaned my brush and studied hard both on silk and on the paper made for oil, which had been sent from Japan. On the oil paper I painted lodgepole pines and impressions; on the silk, a sunset. I took advantage of the shade of the camp tent. Since the paint and materials were very convenient I worked almost without taking a breath. Really, the object is so great that I became absorbed in it.

 Ryder-kun was busy putting leather and a handle on a luggage box. Both of us are just in our underwear, as comfortable as can be.

 For lunch I used a slow heat to warm up some trout I had broiled before.

 When Mr. Sullivan is not giving leftover food to his donkeys three times a day, he sits on a crude chair, smokes a pipe, and tells us old stories, using "God damn son of a gun!" for emphasis, and makes us laugh.

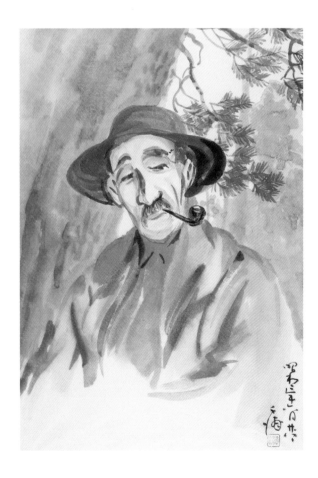

Old Ranger, Tim Sullivan,
28 June 1927.
Sumi and watercolor on paper,
15¾ x 11 in.

This morning I sent the seventh letter. I gave it to a worker who was in the mountains repairing a road and was returning to Aspen Valley.

Has Kimio left for the mountains? Send him a box of twenty-four chocolate candies and some oranges or something.

Has Yuri been well? Teach Gyo how to read *kana* [Japanese alphabet].

June 30 Chiura

To Haru-dono

[JULY 2, 1927, WHITE WOLF]
Sierra Trip, Letter 9

On July 1st I felt I had less energy, although I was not discouraged from sketching. I wondered if I had been thinking of the children so much that I had exhausted my nerves. So, I ate some chocolate and decided to go fishing in the morning. As I was getting ready, a man from Aspen Valley brought the envelope that enclosed the [photo] proofs of Gyo and Yuri, articles by Mr. Shunshuro and Mr. Abe, your letter and the money, and also the package of two sweaters. I went trout fishing and returned at around 11:00. Caught twenty to thirty fish.

In the afternoon I sketched the different wildflowers. In the evening after dinner I sketched White Wolf Meadow.

Tonight, besides Mr. Sullivan, two men who had come to fish were busy talking by the campfire. I came out with my stationery to write a letter when I saw a crescent moon just southeast of the tent. It was really beautiful—a figure of a virgin like a well-protected maiden of Venus in a clear evening mountain sky. I quickly lit a candle and sketched the impression until about 9:30.

I look forward to this evening to see how vividly the only daughter of Venus reflects her beautiful figure onto the trees, the rocks, the meadows, the flowers, and the streams. Since Yuri was born as a female, I want to raise her and have her imagine this very beautiful sight. She smiles a lot and is cute. If she is taken out into the sunlight she will get very dark.

July 2, Saturday

Probably because the Fourth of July is coming soon, many cars, four or five, have arrived.

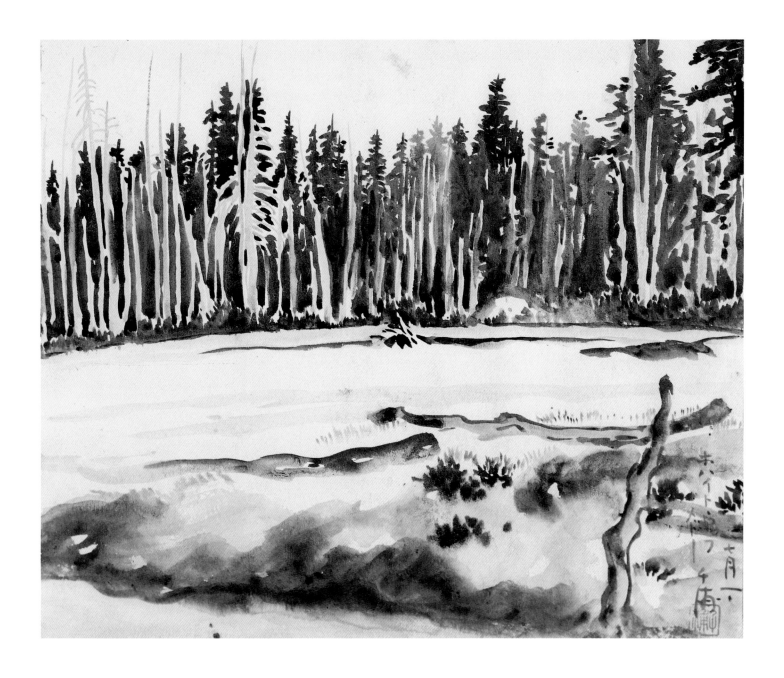

White Wolf Meadow, 1 July 1927.
Sumi on paper, 9 x 10⅞ in.

Since our coming to White Wolf Meadow, the remaining snow in the trees and on the ground has quietly melted. A variety of flowers has started to bloom in competition.

The speed of the universe is surprisingly fast. The uproar of Lindbergh's transatlantic flight is no comparison to nature. To the grand changes of this great nature my eyes, my ears, my hands and feet, and my whole body and mind are reacting at a high speed. In San Francisco I was hardly reacting to the streetcars, automobiles, phones. I was just like a trout quivering its fin in a deep lake.

At a place where yesterday I had thought the snow was three to four feet high, a type of flower that I had never seen before is already smiling today. Even the sky deepens its blue color every day, adding infinite thoughts to the morning sunlight.

The red of the setting sun deepens even more.

The warmth of my sleeping bag increases my dreams every night.

I am trying to paint my best whether it is a tree, or a plant, or a rock.

I am painting wildflowers as much as possible.

Send me two *cho* of *mino* paper and two *cho* of Hibi-kun's brown pad (for pressing flowers). Order from Japan (from Isamu) a lump of *shio* [yellow pigment]. It is gone so don't forget.

I don't know yet when I'll return, so if you want something, send Mi-san [another friend].

July 2 Chiura

To Haruko-dono

Show this to Shunshuro, Hibi, Yoshizato-kun, etc.

On the evening of the 1st I took a bath in the river. It felt really good and I am feeling much better. I realized I probably had not been well because my pores were clogged with sweat.

[JULY 3, 1927, WHITE WOLF]
Sierra Trip, Letter 10

After sending off a letter I went for a walk in the meadow and sketched the shooting stars in full bloom. Then I started to sketch the boulders that had been carried here by a glacier. They made wondrous forms among the trees in the forest, sometimes with the moss, sometimes supporting the roots of pine and fir trees.

Untitled (Granite Rocks), 2 July 1927.
Sumi and watercolor on paper,
15¾ x 11 in.

White Wolf Meadow, 4 July 1927.
Sumi and watercolor on paper,
15¾ x 11 in.

I tried to explore a one-mile area but found no other rocks with the same form. They have vertical lines like a waterfall and their horizontal lines roar like a lion.

The flowers of the creeping pines look like red plum blossoms. They spread their roots in the little sand between the rocks as joyously as a child who has just awakened and washed his face.

It would surely take three or four years to sketch only the meadow flowers.

As you climb up a mountain, 2,000 or 3,000 feet from the valley, the trees change as well as the plants and the flowers. Each plant and insect has its own characteristic form and color.

I went to the big meadow to view the moon. I sat down on a fallen log and started to sketch the meadow as it quietly fell asleep.

I feel a slight chill from the thawing snow in the wind that brushes my face. But I am very comfortable because of the sweater you sent me.

I am drawing a postcard for Gyo by the campfire.

Chiura

To Haruko-dono

[JULY 4, 1927, WHITE WOLF]
Sierra Trip, Letter 11

Tonight will be the last night of our stay at White Wolf Meadow. Tomorrow we will move our base camp to Yosemite Creek, six miles ahead. I have tried hard, but it is impossible to paint the thousands of forms and shapes. Not only that, the air changes every day so that the colors of the sky, the earth, and the different flowers are always changing. As a farewell to White Wolf Meadow, I sketched a huge rock that a glacier had placed on the rock stratum as if it were a cup. Now the rock lies along the Tioga Pass of the Tuolumne Middle Fork. Also, the young pine needles are starting to grow just like chrysanthemums and make interesting designs, so I painted them too.

This morning I got up rather early, so around 11:00 I was hungry and my stomach was making noise. When I got back, Ryder-kun was packing; he was hard at work dressed only in his underwear. I made some fried rice. After finishing a sketch of the pine trees I helped him with the packing. Around 4:00 we began to drive one load to Yosemite Creek. Tomorrow we'll bring the rest

to Yosemite Creek and in a day or two I'll go down to Yosemite [Valley]. I think that Nonaka-kun [a friend] and others are at Camp Curry, so I might be able to see them. In Yosemite [Valley] there are so many automobiles and people that when I looked down from a viewpoint I did not feel like leaving the quiet mountains. But the scenery along Yosemite Creek was so good that I want to sketch it and sleep outside for a night or two.

Also, at the beginning of this week Robert Howard-kun is due to arrive in Yosemite Valley, so I'll go to meet him.

Since tonight is the Fourth of July we shared about five cups of hot sake, which I had so preciously saved. Perhaps due to the air, it was very sweet but not heavy. It was very good. Did you ask Howard-kun about the sake? Ryder-sensei ["-sensei" is a suffix that means teacher] was worried that Robert might drink it all on the way up, so he told him that the sake was sure to be spoiled if the cork was opened before he reached 9,000 feet. Well!

The weather seems to be fine in San Francisco. Is Gyo all right with his tonsillitis? Be careful that it's not too late!

In my last letter I asked you to order some yellow pigment from Isamu, so don't forget to do it right away.

Perhaps my letters are delayed, because once in a while I ask someone to take them if he happens to be on his way back. You seem to have written four letters but only three have arrived. One must be wandering around Carl Inn. Always put your name and address whenever you write.

Show everyone my letters about going down to Yosemite.

Showa 2, July 4 night Chiura

To Haruko-dono

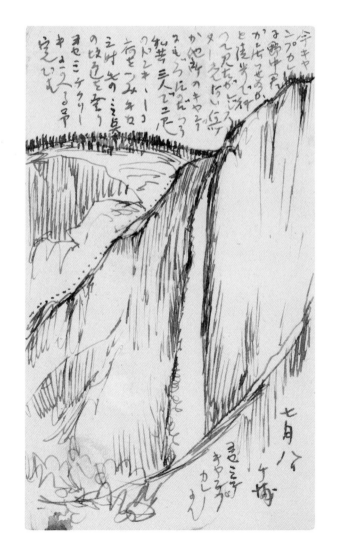

Yosemite Falls, 8 July 1927.
Pen and ink on postcard, 5 ½ x 3 ¼ in.

I just walked to Camp Curry to see if Nonaka-kun was there, but he wasn't registered. He's probably in some other camp. The three of us are going to load two donkeys and at 3:00 climb this dotted slope to go back to Yosemite Creek.
July 8 Chiura
at Yosemite Camp Curry

[JULY 12?, 1927]

Sierra Trip, Chiura, from Tuolumne Meadows

On July 9 after the three of us had a discussion, we decided to leave Yosemite Creek and move on as far as we could. Ryder and Howard-kun loaded about seven boxes of food onto the car and they left at around 8 A.M. to explore. I remained at the camp.

Yesterday evening at about 5:00, when it was still light, while we were talking, a seven-hundred-pound cinnamon bear overturned our boxes of food piled at the foot of a tree about thirty feet away. He was departing step by step with a big cheese. We all yelled out loud but he only left about half of the cheese. Almost every night he comes slowly, slowly, so unless we are very careful he could eat all of our precious supplies. Therefore, I stayed behind as the bear watcher. I sorted the wildflowers I had picked, wrote a journal on Yosemite Creek [published in *Shin Sekai*], and so on.

pages 126–31

In the evening they came back. They had whipped the Ford and struggled hard, passing the steep area of Porcupine Flat, Tenaya Lake, and Snow Flat. They dropped the food boxes on the banks of the Lyell Fork, which could be called the back parlor of Tuolumne Meadows, nine miles away. As it is a dangerous pass with a 27–28 degree slope, it was almost impossible to bring the remaining luggage all at once.

On the next day, the 10th, they loaded half of the remainder and left. Howard-kun stayed behind to watch for bears. Only Ryder-kun came back at around 4:00 P.M. drenched dark in sweat and dust. He told me that it had taken a long time because he had stopped to help people from Minnesota with their two cars, both of which had a broken axle. There was not much they could do on the narrow road.

Having car problems in the mountains is the worst trouble. There is not even a gas station along the thirty-eight miles from Aspen Valley to Tuolumne Meadows. If you run out of gas, you would be stuck without a drop. With everything else as well, there isn't a place to get even a match. Therefore, even if only one cheese is taken by a bear, it means we cannot make a macaroni dish. We even save the leftover pieces of green onion.

Whenever we depart we are careful to have oil, extra gas, and water. We tie a bucket of water, together with the pots with handles, onto the running board, and we hang two donkey bells under the radiator. Ryder-kun drives and I hold my left hand over the horn and keep blowing it, along with the bells ringing, nearly all the time, just in case. Driving like this, every car we meet must think we are a procession of horses, or mules, or donkeys.

Ever since our departure we have not had the slightest scratch to the fender and not a single flat tire.

On July 11 we loaded the last huge load. We bid farewell to Mr. Sullivan, and we left Yosemite Creek at 8:00 A.M. and drove toward the steep slope of Porcupine Flat.

Tuolumne Meadows, 13 July 1927.
Sumi on paper, 11 x 15¾ in.

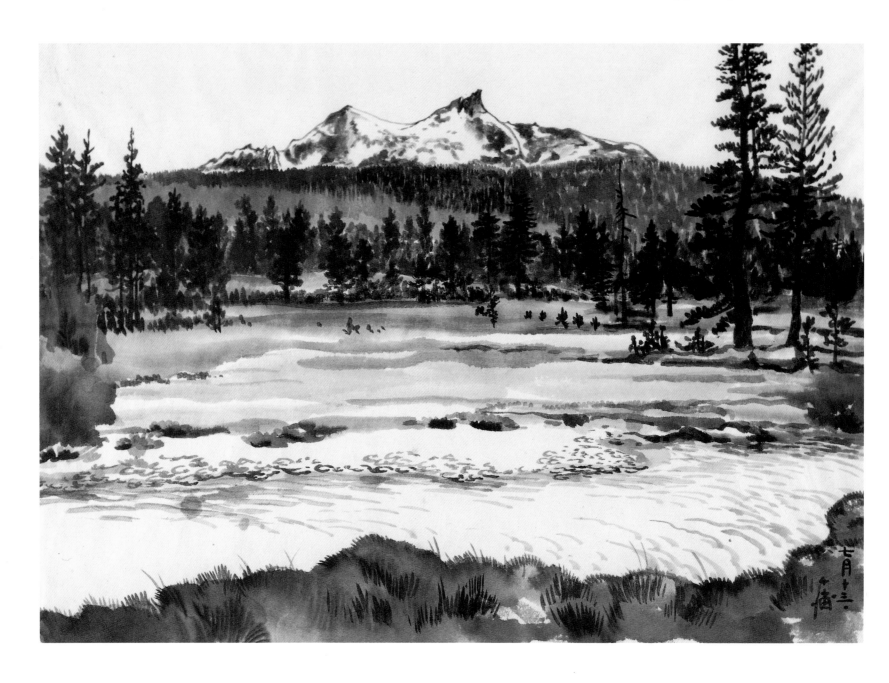

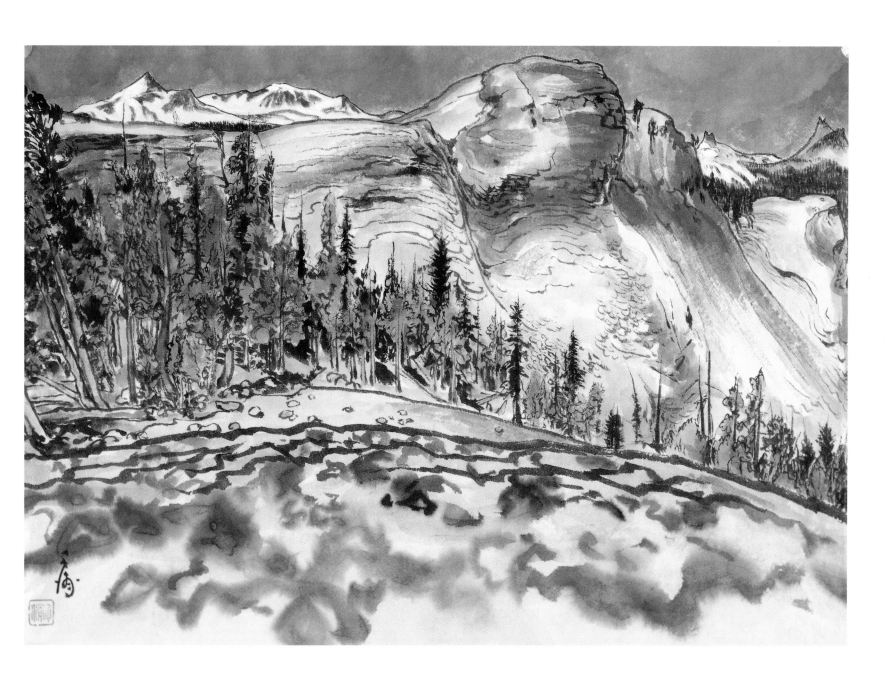

Untitled (Peaks in
Tuolumne Meadows Region), 1927.
Sumi and watercolor on paper,
11 x 15¾ in.

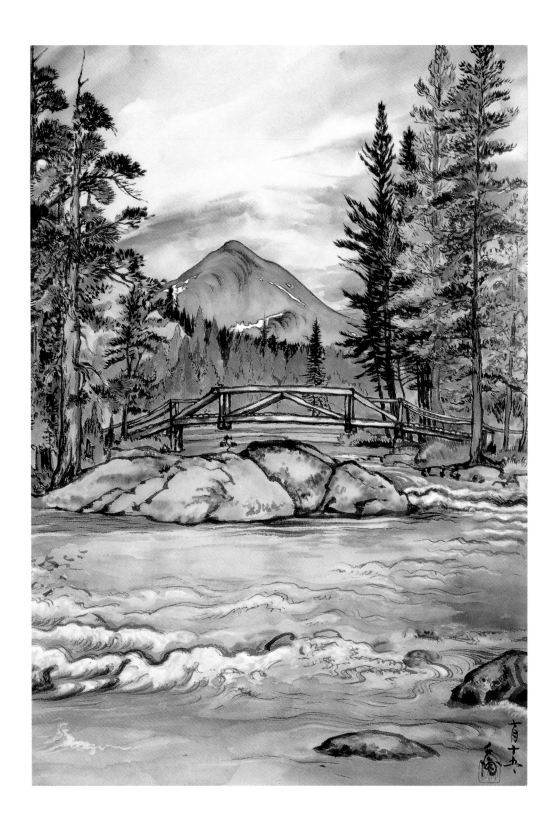

Dana Creek, 15 July 1927.
Sumi and watercolor on paper,
15¾ x 11 in.

[JULY 16, 1927, TUOLUMNE MEADOWS]
Letter 14

I was supposed to leave yesterday, July 15th, but I had made the plan in San Francisco without knowing what I would actually experience. Now, after knowing this abundant, great nature, to leave here would mean losing a great opportunity that comes only once in a thousand years.

Luckily, Ryder-kun has brought plenty of food. It is all right with both of them to return before August 10. I would like to study at least until the end of this month, so plan on that.

The view of the divide of Nevada to the east and California to the west could be called the essence of the Sierra and cannot at all be compared with Yosemite Valley. All the mountains are 12,000 to 13,000 feet high. There is a glacier and there is a rocky mountain of red-colored rocks. Next to it is a granite mountain covered with snow. The lakes are silent and hold deep, deep tranquility.

There is a long stretch of woods where large pines had been knocked down by an avalanche. They are buried among the flowers of young, shooting weeds, their bodies lying side by side like samurai who have died on a battlefield.

Now I am going to Ragged Peak, 11,000 feet high, to collect arrowheads and to sketch a battlefield where the Indians fought.

I have about $20, but when I come back I'll stay overnight someplace and the luggage will be expensive so I think I will need about $15 more.

Chiura

To Haru-dono

Chiura Obata
c/o W. Ryder
Tuolumne Lodge
Tuolumne Meadow
via Yosemite

Arrowheads, 1927.
Sumi on postcard, 3¼ x 5½ in.

Gyo-chan—I'll go to the place where the Indians fought and try to find arrowheads and hatchets to bring you.
Papa

[written in English]

Dear Kimio,

I received your postal card 14th and today received your letter which dated July 5th. Same time I got mother's letter dated July 7th. It's 7th letter she wrote to me. Also package of rice paper and sketch pad. When I received your postal card I thought will write to you, but you didn't write your address clear. Any way I am glad that I hear you had such nice time in the mountains. I think some day when you grow up you will realize the power of great nature which gave to humans such wonderful education both mentally and physically. I am having good busy time to study. Every morning get up about 5 A.M. After eat most every day go up some different mountain or lakes. The Tuolumne Meadow is one of last largest meadow on high Sierra along Tioga road. Our camp is on the bank of Lyell Fork. This creek runs down from Mt. Lyell 13,550 feet and we are only 8 miles from this great mountain. Yesterday we went Unicorn Peak, 10,950 feet. In near future will go up to Mt. Lyell. Stay over night over there then make some sketches. July 14th went to old Tioga mine which discovered 1876. Same year they built road from Carl Inn to Tioga, 65 miles. I think they did wonderful work in such early year, especially high altitude like Tioga Road. The Road itself 9,941 feet high and both sides surrounded higher mountains or deep canyons, but I thanks to those people who opened this road. For many years countless people saw these great, great views of nature. When I bring back all my sketches you will see what kind country this is. I am very strong. Mr. Ryder and Mr. Howard are strong, but I never late to go climb mountain. I can make 1,000 feet climbing and get back 1 hour and half. Carrying three person's lunches and tea pot, sketch material all in nap sack. Next time you try beat me you will find very hard one to beat to climbing up high mountains. I am as dark brown as bear. Whenever we go up mountains we take out all upper clothes.

I sketched last night until 12 P.M. on the meadow 2 miles from my camp, and got up this morning 5. So I am sleepy. Take good care for every body. Do not scold Gyo. Tell him, teach him with kind heart.

Tell Fred what I am doing. I will be back home in this month.

Write to [your grandparents in] Sendai [Obata's hometown] and Fukuoka [Haruko's hometown]. Tell them that you were in Camp McCoy and what you thought about.

Good bye Father

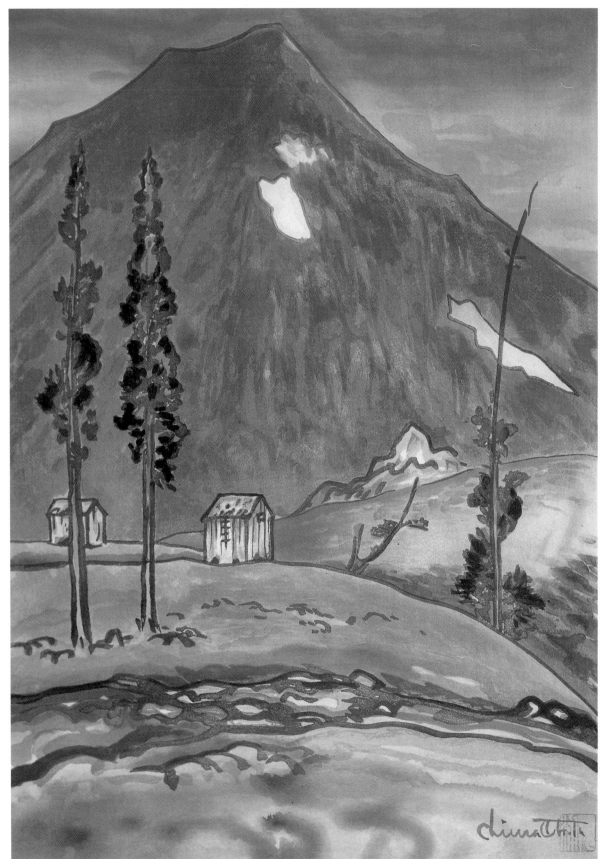

Ruin of Old Tioga Mine, 1930.
Color woodblock print, 15¾ x 11 in.

Bare of all trees, the copper-colored mountain bows its head, speechless, and gazes upon the tattered cabin that stands melancholy at the foot of the mountain, the cabin in which once dwelt eager silver miners, full of energy. Upon the mountainside are seen scattered spots of perpetual snow.

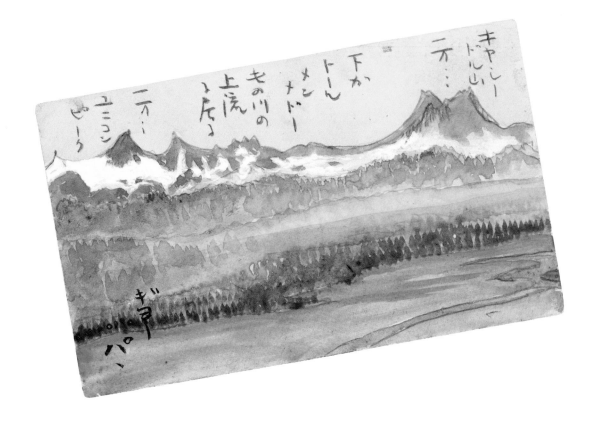

Tuolumne Meadows, 1927.
Sumi and watercolor on postcard,
3¼ x 5½ in.

To Gyo, from Papa
Below is Tuolumne Meadows; we
camp at the headwaters of the river.
Unicorn Peak 10,000
Cathedral Peak 10,000

JULY 21 [1927, TUOLUMNE MEADOWS]

I lost the Elizabeth Lake trail three times as I made the climb to Johnson Peak.
Pieces of the glacier hammered down loudly, right and left, from the top of
10,000-foot Johnson Peak, as if the ice were cracking. The white rocks, both
large and small, have sharp edges and look just like lumps of cracked ice.

Of the trees there are only juniper and five-needle pine growing low, one
to two feet at the most. On the ground are a few flowers crawling in between
the cracked white rocks: red-colored, white-lined wild chrysanthemum-like
blooms, and white and yellow grassy flowers scattered here and there.

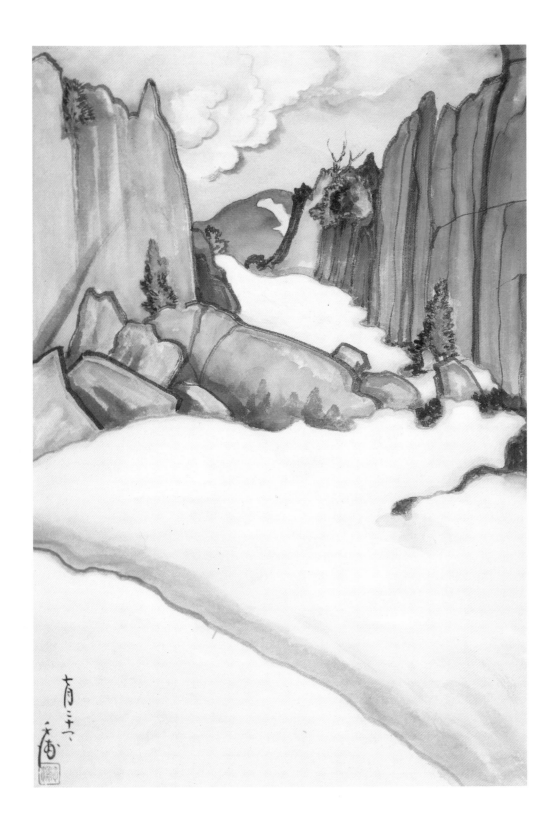

Color Composition,
Top of Johnson Peak, 21 July 1927.
Sumi and watercolor on paper,
15¾ x 11 in.

After the passing of a thunderstorm, the freshly brightened colors vanish as the evening falls. As the deep blues turn to purple, one can still hear the melody of a thousand streams. In the silence that follows, Nature reveals herself.

Silence, Last Twilight on an Unknown Lake, Johnson Peak, 1930. Color woodblock print, 11 x 15¾ in.

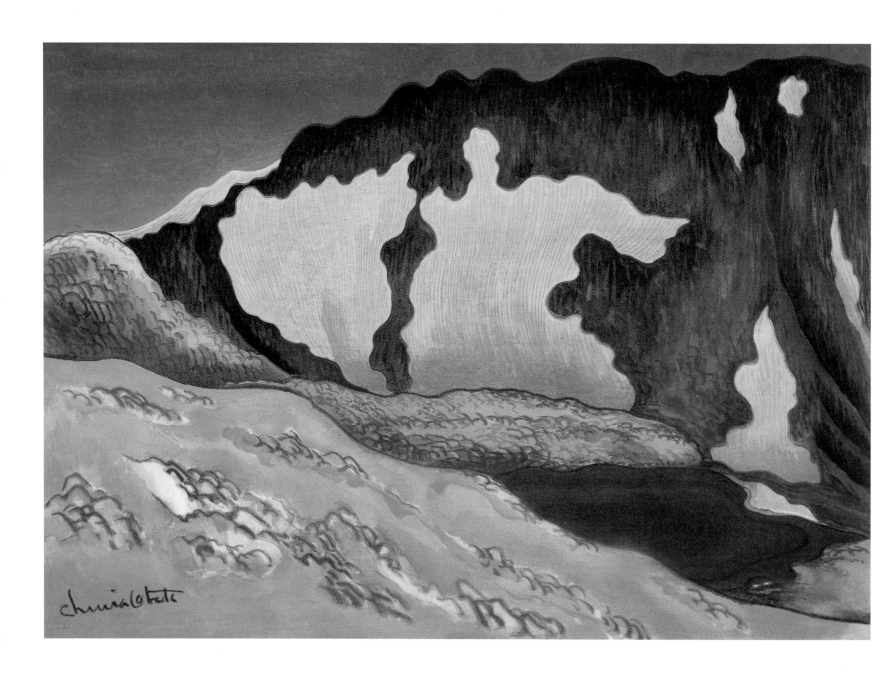

After following several creeks, I reached 9,000 feet. Here lies a flat area about five blocks wide where the soil had crashed and flowed down. Sierra gentian and other plants spread their roots, blooming yellow and red flowers through the remaining snow. A creek twists and bends; here and there it flows five to six feet deep underneath the snow in the small meadows. This is the kind of scene I would like to show to Korin [eighteenth-century Edo period painter].

I crossed many of these streams. Then I climbed about 500 feet, stepping on the snow between the steep, white rocks, until I reached a basin of one or two miles across. There were two small lakes and one lake of about a mile-and-a-half circumference on the western edge looking as if ultramarine had been put into a white vessel. The towering rocks in the east, south, and west were like screens. There was not even a ripple in the lakes. I heard only the sound of melting snow flowing quietly somewhere. As I stood on the shore gazing into the beautiful water, hundreds of vivid-colored frogs were jumping in. I caught a few as souvenirs for Nonaka-kun, but I let them go in case they might die.

I climbed another 600 or 700 feet up to the top of the peak. In the east was Mount Dana at 13,000 feet, Mount Gibbs, and the Kuna Crest at 12,500. The glacier on Mount Lyell was the farthest and the largest, and the ridges of McClure were heavy with snow. In the northwest behind Unicorn Peak was Cathedral Peak.

frontispiece

I took out a brush, rinsed out the inkstone, and sketched for an hour or so. As I was looking at the white snow on Mount Dana, the gathering clouds darkened the snow and before I knew it, the sky above Mount Lyell in the south was covered. When I turned around to look behind me, the rain had already broken through the clouds from the direction of Tuolumne Meadows. Then, right away, a crash of thunder roared, and there was an incredible echo throughout the ridges and valleys.

It was raining too hard for me to apply the colors without the shelter of trees or rocks. I put them away in my knapsack and instead listened to the thunder of the mountain storm. Although I knew I was in danger of being struck by lightning, it would have been easy to break a bone if I hurried and slipped on the bladelike rocks. Many people lose their lives in the mountains when they step through the melting snow or fall in between the rocks, perhaps breaking a leg. They call for help but no one comes until at last they die. Since I heard these stories I take my time in going down, being careful not to slip.

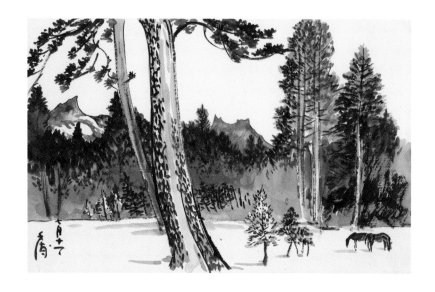

Untitled (Tuolumne Meadows),
22 July 1927.
Sumi on paper, 6½ x 10¼ in.

JULY 22, [1927, TUOLUMNE MEADOWS]
Mountain Rain and Thunder

The white clouds floating in the sky all morning created an interesting design through the trees.

Howard-kun and I had planned that today we would borrow Mr. Sullivan's two donkeys and go visit Matterhorn Canyon for six days. But one donkey has a wound in his chest that is not healing well, and Mr. Sullivan feels it is not ready for packing. So we have decided to wait until the donkey's recovery, and I organized my different sketches in the camp.

A little past 3:00 Howard-kun and I climbed onto a 200–300-foot rock across the river from camp. Rumbling thunder, lightning, and showers had just begun and we wanted to see the scene. I started to sketch the rainy view of distant Tenaya and Dana mountains. Before I could finish it, the shower, carried by swift dark clouds, wet the paper in one stroke without even giving me time to flip the sketch board.

A paradise for lovers of the out-of-
doors is found here, a spot along the
Lyell Fork, which cuts through the
Tuolumne Meadows. Nameless flowers
are found blooming here in profusion,
and wild herbs that are delicious to eat
with trout. Clouds sail lightly and
joyously over the high plateau. The
soul and mind of man are lost in the
supreme beauty.

Clouds, Upper Lyell Trail,
along Lyell Fork, 1930.
Color woodblock print, 11 x 15¾ in.

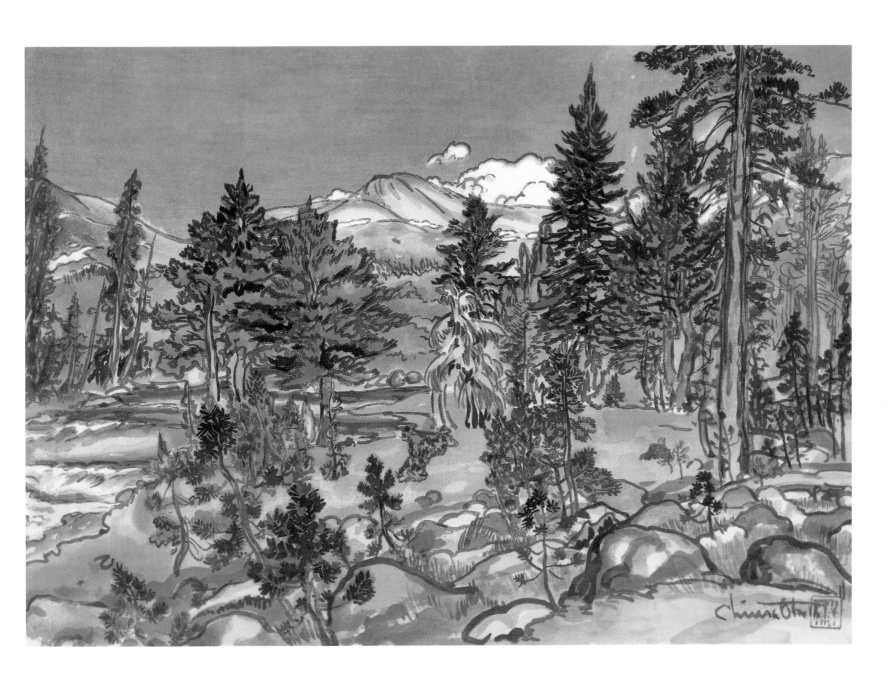

Like a sleeping lion the Lembert Dome rests unconcerned in the center of the Tuolumne Meadows, walled in by a train of high, surrounding rocky mountains. He sleeps in the midst of an approaching storm. Thunder rumbles and roars through the vast meadow, like a huge orchestra at the height of its frenzied rendition of an overture, announcing the coming of a storm. But the dome, like a lion, sleeps unconcerned.

Before Thunderstorm, Tuolumne Meadows, 1930. Color woodblock print, 11 x 15¾ in.

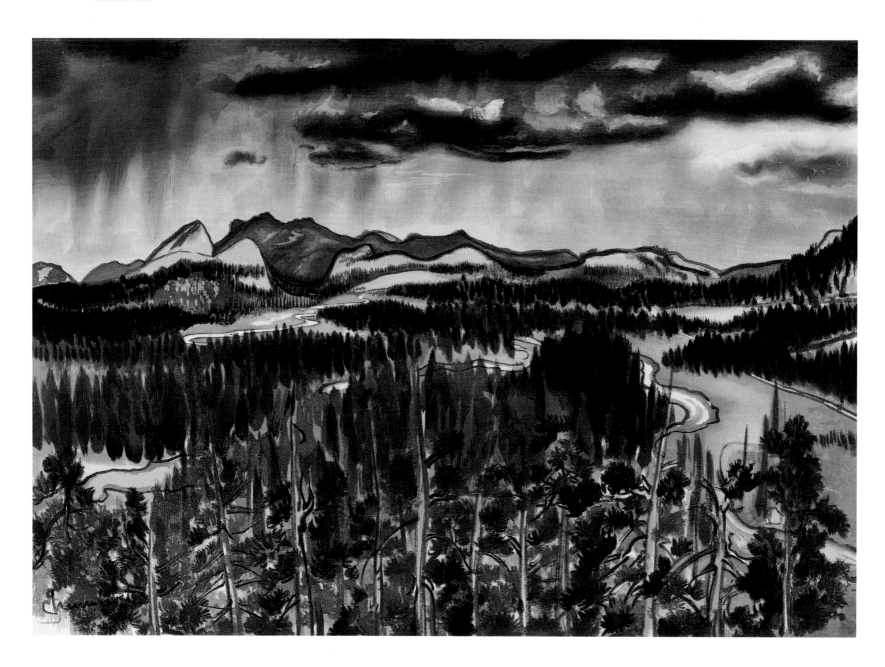

Both of us got soaking wet. We crossed the river and came back to camp. After changing our clothes, we warmed ourselves by the campfire.

If it is sunny, we can see people fishing for trout along the river. However, when clouds move ominously in the sky, you cannot see even the shadow of a fishing rod. Everyone must be hiding in their tents.

Mr. Sullivan heard at the ranger station in Tuolumne Meadows that a newlywed couple who left yesterday morning for Booth Lake seven miles away seems to have gotten lost. A rumor among the campers is that they might have fallen into a ravine.

[JULY 23, 1927, TUOLUMNE MEADOWS]
Letter 16

I am planning to come back to San Francisco by the end of this month, or August 1 at the latest. I asked in my last letter for you to send about $15 by special mail for my luggage. Have you sent it?

Howard-kun and I are going to walk the thirty-some miles of the Merced Lake trail. We'll see Little Yosemite Valley and others. We'll stay overnight in Yosemite, then take the train back home.

Yesterday morning we had a storm: rain, thunder, and lightning. Each brought a change in atmosphere and sound. It was very active and at the same time very exciting.

On the 19th I climbed the 11,000-foot Johnson Peak by myself. This was a good experience for me. I had the sumi [ink stick] and diary in my knapsack but I lost them. The sack must have caught on a tree or rock during my climb because a large hole was torn out. On the 20th I climbed it again by myself to look for the sumi and the diary. Although I didn't find them, I saw rain and thunder on the peak, and I was able to do sketches I hadn't done before.

Luckily Ryder-kun had the sumi that he had bought in Paris, so I am using that.

July 23 Chiura

To Haru-dono

Letter 17

This morning when I went to get melted snow water I found forget-me-nots starting to bloom. They say it starts snowing here as early as September 22 or 23, but it is now the end of July and it seems like the middle of spring.

The sky in the morning and in the evening, especially the sunset, has increased in redness day by day. Last night it was beautiful beyond description.

As the donkey is wounded and we cannot use him, we are considering driving the car to the Nevada border to see the sunset in the desert. But even around here at camp I can sketch as much as I want.

There is a vegetable about three feet high of a jadelike color. Its flower is pale purple and very beautiful. It is quite tasty for salad and for stuffing trout.

Did you send the money? It hasn't arrived yet.

July 25 Chiura

To Haru-dono

JULY 26, [1927]
leaving Tuolumne Meadows, crossing Tioga Pass, and camping at the ruined cabin of Mono Mills behind Mono Lake [written on envelope]

We didn't have time to wait for steady weather, therefore we decided to descend the 4,000-foot slope of the infamous Tioga Pass like tightrope walkers along Lee Vining Creek.

page 34

It is a wonder that the nature of the east and the west sides is different in the color and form of the trees and grass, just like the water that divides Dana and Tioga.

When we reached Mono Lake the tranquil lake did not even ripple. A mysterious feeling overwhelmed us. It was beyond description.

page 35

We passed the eighth stage of Mono Crest (9,000 feet) seventeen miles away from the lakeside Tioga Inn.

During the 1870s, when the mining fever at Tioga and Bodie reached its peak, all the cedars along Mono Lake were cut down. These were the only woods on the Nevada side.

At the ruins of Mono Mills the large machinery of the mill has decayed, creating a gruesome feeling that makes one's hair stand on end.

Man stands enthralled at the sight of the evening glow at Lyell Fork during the late summer when, for only a moment, the streaks of clouds in the sky are transformed to bars of brilliant gold. Tamarack [lodgepole] pines growing in profusion along the fork darken their shadows as the evening deepens. The Lyell Fork River runs southwest to the northwest of Tuolumne Meadows, the highest plateau in the Sierra.

Evening Glow at Lyell Fork,
Tuolumne Meadows, 1930.
Color woodblock print, 11 x 15¾ in.

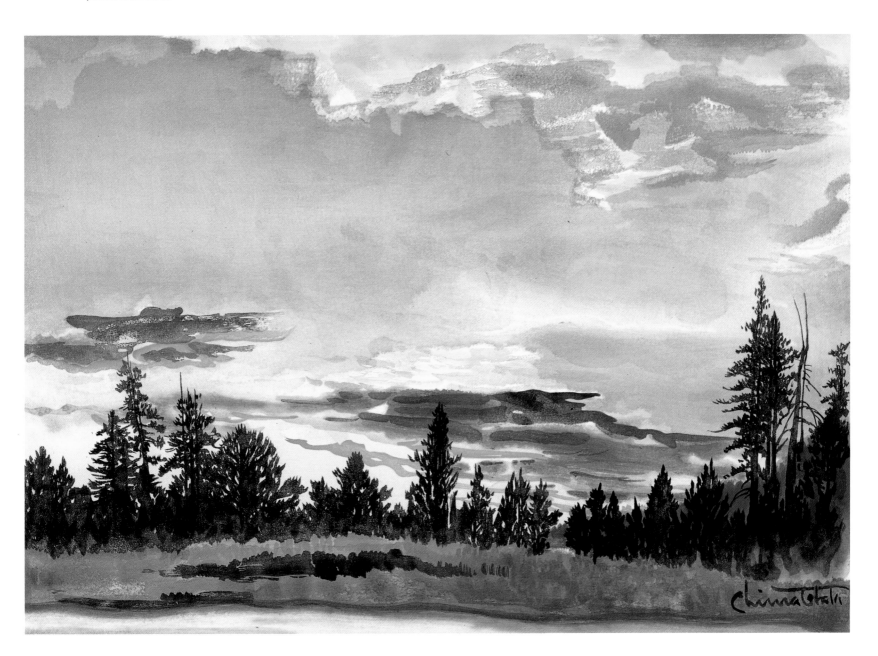

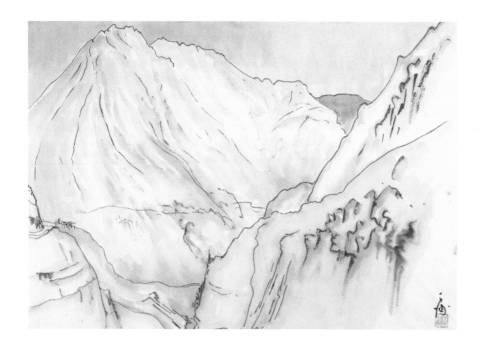

Tioga Pass, 1927.
Sumi and watercolor on paper,
11 x 15¾ in.

There is no water source due to the deforestation. After a while we found a tank two or three blocks away the same as it was before. We gathered hay in a run-down cabin, the only cabin left, and decided to spend the night.

We have finished our dinner of fried rice, which I cooked. Ryder and Howard-kun have gone off to explore one or two miles away. I am watching the lake by myself. Dark clouds are gathering and it's getting windy in the southwest sky. It feels like it does before a storm.

But the mysterious Mono Lake remains colored from pale green to deep bright blue, and from deep blue to purple and purple-blue. In the distance Mount Dana and Bloody Canyon show a sparkle of thin, white snow in front of the curtain of the bright golden sunset. Even in these intense colors the night curtain falls ever so quietly.

JULY 27, [1927]
from Mono Mills to Mammoth Lakes until the stay at Lake Mary
[written on envelope]

Got up around 4:30 A.M. Although the rain from last night cleared up, it was still cloudy. I quickly finished breakfast and began to sketch Mono Lake. It was wondrous the way the rays of sunlight through the clouds changed color within a few seconds, depending on how the clouds passed.

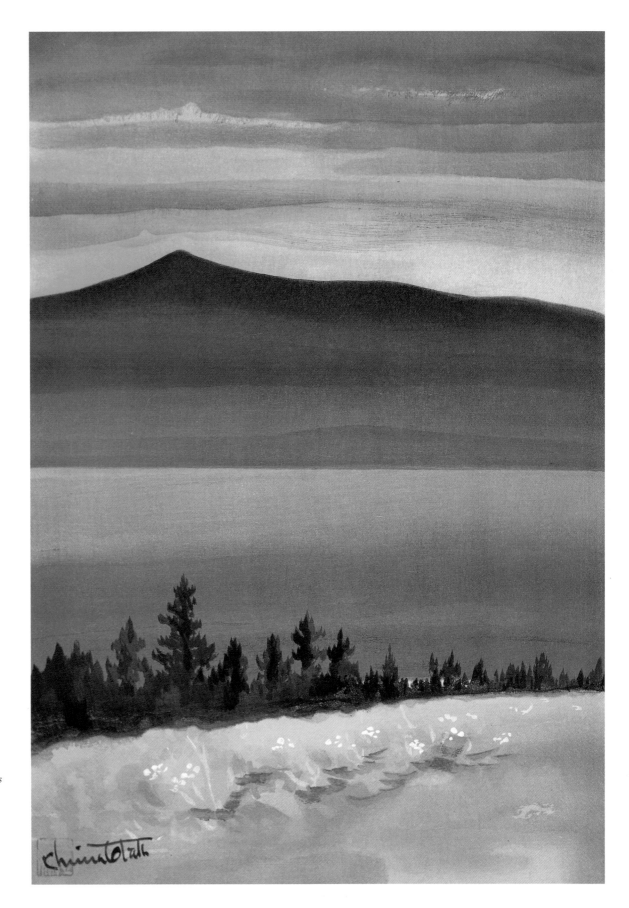

Evening Glow at Mono Lake,
from Mono Mills, 1930.
Color woodblock print, 15¾ x 11 in.

The last glow of the dying day enfolds
the storied Mono Lake and its
surroundings with mysterious tints
and hues.

A thunderstorm had washed the entire
pine forest here the night before. But
the morning brought with it peace and
tranquility. The ever-refreshing sun
pours its glorious rays upon the high
Tioga Peak, and the cool morning
breezes gently shake the silvery dew
off the pine needles.

Morning at Mono Lake, 1930.
Color woodblock print, 11 x 15¾ in.

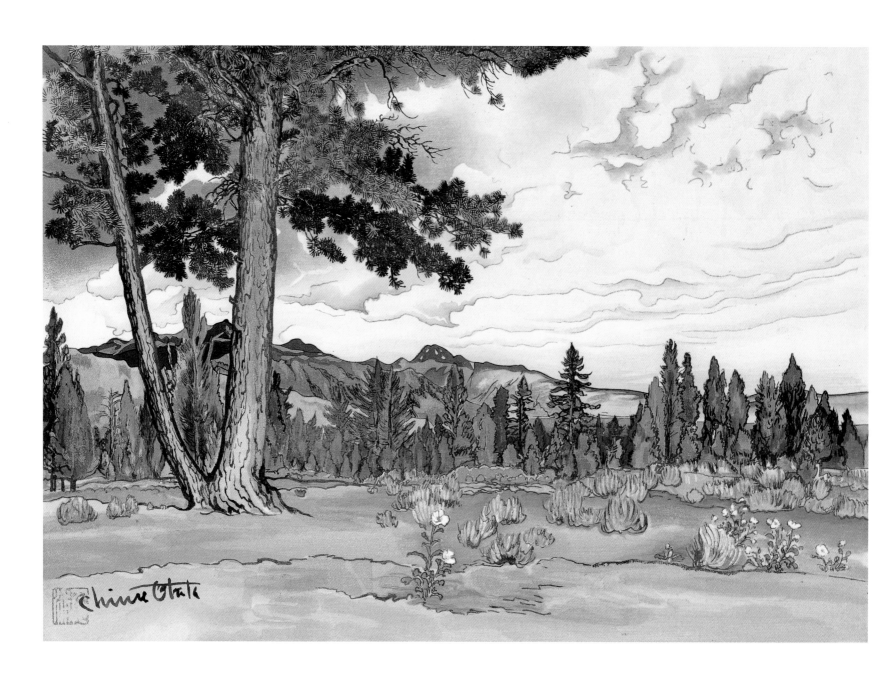

At about 8:00 I heard a bell ringing across the desert, which, as far as I could see, was covered with whitish green sagebrush far below the lake in the northwest. There are four or five houses near the Mono Lake post office about seventeen miles away, and I thought there must be a fire.

About an hour later two donkeys wearing small bells, not a fire bell, around their necks came up to our decayed cabin. They each carried a heavy load on their backs and were pulled by two shepherds in blue overalls holding sticks.

"Good morning. Where did you come from?" I asked. They said they were from Bakersfield and that they were herding twelve or thirteen hundred sheep by crossing so many mountains and valleys, not to mention the Sierra mountains. Right away they unloaded the donkeys, dug the soil of sand and pebbles into a hole one to two feet square, gathered twigs, and cooked breakfast. They were so experienced that it was all done quite casually.

These two brothers had grown up in the mountains near the border of Spain and France. They were employed by an Italian named Orsini, who used to be a shepherd himself but had worked his way up and is now a rich man in this area. They led the flock of sheep by following the new grass.

From about 11:00 the sky darkened and it began to rain hard. Although the cabin was run-down, it had a roof and a floor, so I chose a spot where there was no leak and continued to sketch.

When the rain lessened at around 1:00, we said good-bye to the two shepherds and left for Mammoth Lakes, twenty-three miles away. After four or five miles we got out of the car to walk to a crater. It stood a few blocks ahead to the right of the path with Mono Lake in the background to the left. The crater had seemed only a few blocks ahead but it was actually quite far and it took us about an hour. We saw volcanic rocks and melted rocks. I picked up a few as souvenirs. The flowers blooming near the crater were varied and interesting.

After driving about ten miles it began to rain so hard that we had to change our direction, and we turned left to Big Springs. Within four miles we arrived. There was some water of the Inyo county park and many campers. The atmosphere there was that of Los Angeles rather than of nature. The Auto Association of Los Angeles had put up many signs saying that it would dedicate this county to the people. This was in bad taste and the place wasn't interesting to us. Luckily the rain eased up, so we drove off.

Finally we passed Mammoth Lakes and four miles later we got to the shore of Lake Mary after 7:00.

*In contrast with the beautifully
smooth, undulating growth of
sagebrush along Mono Lake below,
the Mono Crater presents a weird
and awesome beauty with its
sharp-pointed, rugged, and
variformed shapes.*

Mono Crater, 1930.
Color woodblock print, 11 x 15¾ in.

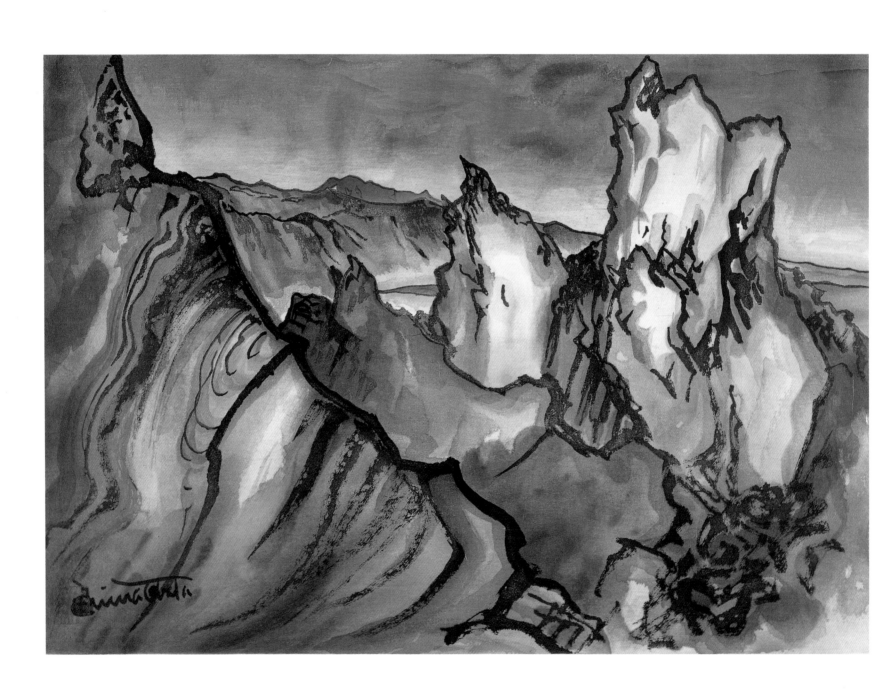

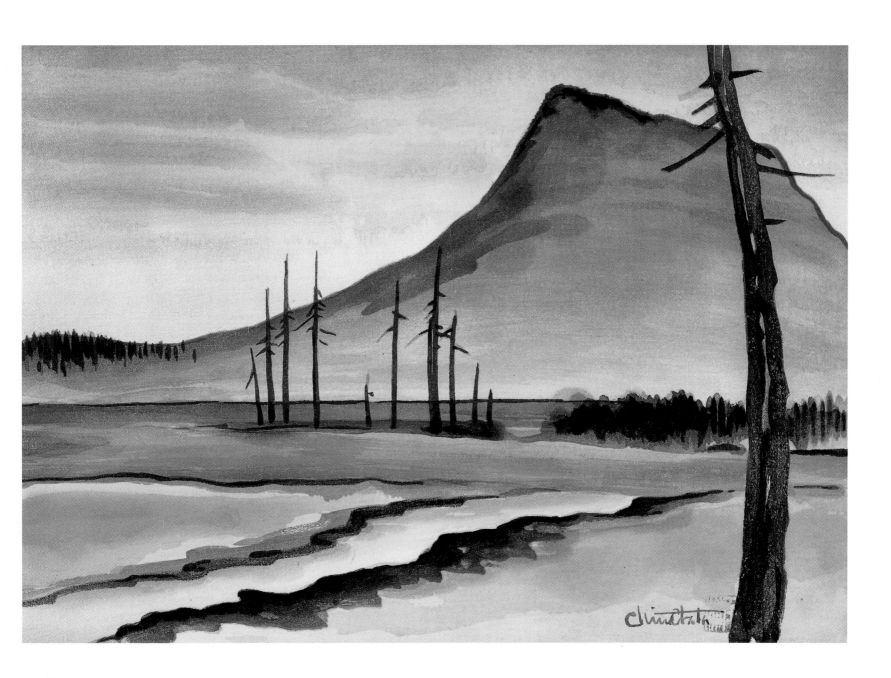

Silence reigns supreme here around Mammoth Lakes in the High Sierra. In the lakes are found trees standing dead, lonely, and silent. Crisp, chilly morning breezes blow softly, caressing the surface of the icy water.

Lake Mary, Inyo National Forest, 1930.
Color woodblock print, 11 x 15¾ in.

Lake Mary, 28 July 1927.
Sumi and watercolor on postcard,
5½ x 3¼ in.

Southeast direction.
Yesterday we left Mono Mills by Mono
Lake. Thirty-five miles to the south we
passed Mammoth Lakes and spent the
night at Lake Mary. From 7:00 this
morning we hiked a seven-mile
mountain path to see the Devil's
Postpile area.
We are by a mountain lake, a few
hundred feet higher than 10,000 feet;
therefore it is very cold. We had frost
this morning. We'll be here tonight and
tomorrow morning and probably
won't get back to our camp at
Tuolumne Meadows until night, since
it is fifty miles of mountain road.
morning, July 28 Chiura

Devil's Postpile and Rainbow Waterfall

On July 28 we ate breakfast with a view of the morning frost on Lake Mary. Then, with our knapsacks on our backs, we first walked the nine and a half miles of mountain trail to Devil's Postpile.

We walked along the east, the south, and the west sides of Lake Mary, almost circling it. We climbed a trail, which was mixed with sand and pulverized pumice stone, in between Mammoth Peak on the right and a round mountain of about 10,000 feet on the left. We also climbed a trail full of yellow pines. After two miles we reached Horseshoe Lake, shaped like a horseshoe. Very few people must fish there because we saw the trout making ripples on the surface of the lake.

We climbed about 1,000 feet to a pass. From the two lakes of Mary and Horseshoe far below us there spread to the east a great desert of sagebrush. It could be described as spreading for a thousand miles. At the edge of the desert, like a serpent, were three layers of mountain ranges. They are the famous White Mountains of the state of Nevada that scrape the blue sky. The floating clouds along the crest rose far above the last layer of the range.

From this lookout point at the summit of the trail, the mountain path went downhill. We walked down about 1,500 feet, eight miles or so, in cool silver fir woods. Then we found a hot spring by the trail. It was set up with logs, and anyone could bathe in it. The three of us took a long, hot spring bath and we felt great. Two streams ran from the higher mountains on either side of the hot spring. All around were aspens and primroses; it was as if a carpet of brocade had been laid down.

After another mile or so Devil's Postpile was on the right, and on the left in the south was the Minaret Range rising 12,500 feet into the sky. In the middle was the source of the San Joaquin, the longest river in California. Strangely enough, it ran to the east due to the geography.

Devil's Postpile is a memento of the volcanic action of Mono Crater's eruption. The piles of rocks are in rectangles, pentagons, hexagons, heptagons, and octagons, two to four feet high. At the back of the exposure are black granite pillars standing straight about 200 feet high, or some are leaning as if they are starting to melt. It is as if chopsticks hold up thousands of pieces of noodles. Tens of thousands of blocks of broken pieces are piled at the bottom. I climbed to the top of the pillars where large pine trees are growing. The cut sections of the pillars on the exposed end are like mosaics. Apparently the eruption had taken place before the glacier because the cut sections

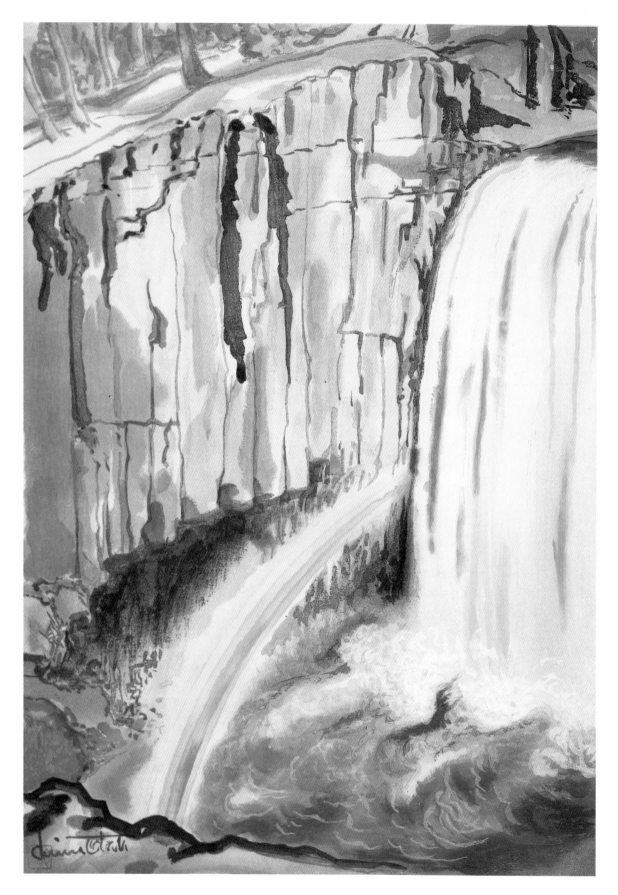

Rainbow Falls, Inyo National Forest, 1930.
Color woodblock print, 15¾ x 11 in.

Near the top of the San Joaquin Peak in the High Sierra is found Rainbow Falls, forming the headwaters for the two largest rivers that wind through the soil of great California, the Sacramento and the San Joaquin rivers. Beside the falls is seen a beautiful rainbow, present all the while the sun is up.

have glacier polish, as is characteristic of rocks in the Sierra.

The two sides of the middle fork of the San Joaquin River, the south shore and the north shore, are very different in character. On the north shore there are straight-standing stone pillars like Devil's Postpile or rocks like a waterfall. But on the south shore, around Rainbow Waterfall two miles away, there were only big round boulders and granite.

About five minutes from Devil's Postpile there is a mineral spring in the river where the two streams meet. It tasted good. We heated tea and had lunch. Then we went down to Rainbow Waterfall. It is about 200 feet high and falls toward the southeast with sharply cut sides like screens. A beautiful rainbow draws two layers of a half circle. It took me a few hours to sketch it. Finally we left at 4:30 P.M. We climbed and climbed the shortcut path of seven and a half miles and returned to Lake Mary at 6:30.

Please keep and do not lose all the diaries and letters, as I will organize them when I come back to San Francisco.

July 29

We left Lake Mary this morning and we are going back to the base camp at Lyell Fork in Tuolumne.

After we pack our luggage and send it off, Howard-kun and I will walk down to Yosemite [Valley] and return home.

Chiura

To Haru-dono

[JULY 30, 1927, TUOLUMNE MEADOWS]
Letter 18

Yesterday, on the 29th at around 4:00 P.M., we came back from our trip to Mono Lake and the source of the San Joaquin River. I received the $20, which had been sent from San Mateo. I'm sorry to hear that the weather has been bad in San Francisco. Here it has been rainy and cloudy for the past few days, but we do not let it bother us since we have no control over good or bad weather.

Evening at Carl Inn, 1930.
Color woodblock print, 15¾ x 11 in.

At the crossing of the Tioga Mountain road, which runs from east to west, and the Yosemite road, which runs south to north, stands the Carl Inn. It is said to have been built way back in 1872. The spot brings up a vivid picture of long ago in which some sturdy pioneers are refreshing their tired nerves and preparing for another lap of the onward march westward. The deep murky fir grove darkens. The air is mysterious.

Howard-kun and I will probably leave here tomorrow. We have changed our plans and will go back down to Carl Inn. We'll stay there overnight and leave at 8:00 A.M. on the 1st. We'll probably arrive in Oakland around 8:00 or 9:00 at night, and I'll get home at 10:00 or a little after. So, be ready and have a bath ready.

Tell this to Hibi, Yoshizato, and Shunshuro-kun.

I am full of gratitude as I bid farewell to these Sierra Mountains. From the deep impression of my experience there springs an emotion which others may not understand. I am looking forward with pleasure and hope as to how I will be able to express this precious experience on silk.

July 30, 1927

At the shore of Lyell Fork Creek, Tuolumne Meadows

Chiura

To Haru-dono

Sierra Trip: Yosemite Creek

"Sierra Trip: Yosemite Creek Impressions, Following the Old Mountain Path from the Upper Part of Yosemite Falls down to the Valley" [Published in the Japanese newspaper *Shin Sekai* in parts, over a period of days, in 1927.]

PART 1 [excerpt]

Yosemite Creek is located north of Yosemite Valley. The origin of Yosemite Creek is Mount Hoffmann at 11,000 feet. This noble, clear river runs through granite rock formed by a glacier. The river turns into the immense Yosemite Falls. This waterfall makes the music of heaven; it is music more inspiring than man-made music.

PART 2

We stayed ten days at White Wolf Meadow. Here, we were able to experience the endless diversity of great nature. However, compared to the size of nature, my experience was very small, like a poppy seed.

After waking up in the morning I wash my face in the creek. The water is made of melted snow, very cold, but it is still soft; when I dissolve Japanese paints in the water, they dissolve very gently. During the day it is very hot, by dusk it becomes cooler. At night I'm warmed by the campfire. Before 9:00 I take that warmth with me into the sleeping bag. From the base of the trees I count the stars. I go to dream to the melody of the creek and the song of the frogs in the meadow.

This experience is nothing compared to nature, but I would not exchange this unforgettable, invaluable, heartfelt memory, like shining stars among the trees. Nature is such a nourishing experience I felt almost sad to bid it farewell.

PART 4

We've been acquainted with Mr. Sullivan since Carl Inn, so we were able to borrow his two donkeys. We packed the food and painting materials into the boxes and put the sleeping bags on top.

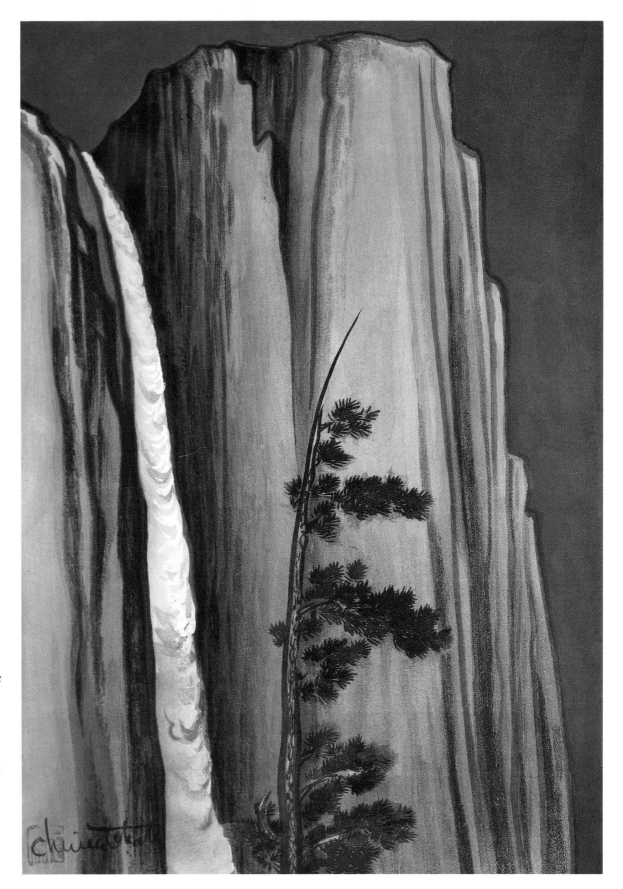

Evening Glow at Yosemite Falls, 1930.
Color woodblock print, 15¾ x 11 in.

From the skies it seems to come roaring and thundering down, the Yosemite Falls. Its sound echoes and re-echoes back and forth from the high mountains in front, vibrating throughout Yosemite Valley with its marvelous and stupendous music. Upon the tops of the walls of a massive rock, which stands perpendicular beside the fall, are thrown the last brilliant rays of the setting sun.

We left the tent at Yosemite Creek campground on July 7 at 9:00 in the morning. There was no one else on the trail, but by following the donkeys we would never get lost. We were both half naked, wearing only pants. For three hours we walked up and down by the river, then after another half hour we reached the origin of Yosemite Falls. We unpacked our gear and freed the donkeys to feed themselves. The donkeys went into a field of flowers. We prepared camp, sketched, and collected wildflowers.

I have no words to express the beauty of the wildflowers. It would take two to three years to sketch all of the flowers. Everything is so beautiful. The trees and grass are set against a background of rocks and ground: green, red, black, yellow, and reddish earth. For example, pansies blooming in three colors: purple, white, and yellow. Sand dunes, formed of red and white broken rock, covered with the purple of clover. Indian paintbrush vivid red in between the white rocks. The three-petaled white Mariposa lily. The tiger lily with five petals in the front, five petals in the back, and five holes in the center. The heather blooming like a cloud of pink flowers on white rocks.

I heard from many people in the mountains that this year was a good rain, so the flowers are blooming well.

PART 5

The day is long so we washed our bodies and clothes. The stew made by Mr. Ryder was delicious. We went to bed early in order to wake up early the next morning.

I gazed up at the huge, yellow pine tree—the moon was shining. It seemed like I could count each needle.

On July 8 we woke up after 4:00 A.M. I cooked breakfast by gathering dry twigs and pine needles. We put four boxes of food in between the trees, covered them with our sleeping bags, and put rocks on top. We put just the two boxes on the donkeys and we carried our sketch books.

We started down the trail at 6:30 A.M. and soon we reached the top of Yosemite Falls. Alongside the trail there was a garbage can for hikers. It was a mess because a bear had knocked it over. We were on a rocky trail below Eagle Peak, 8,000 feet high. With the sound of the donkeys' bells, "cha-ran, cha-ran," we walked down the trail which looked like the edge of a saw: up and down and zigzag.

We saw people, including women, coming up the trail so we put on our clothes. We've been naked in the camp and on the trail; it is good to be naked in hot weather in the mountains.

Mr. Ryder wears a light yellow shirt, blue overalls, and a visor instead of a hat. I wear my old fishing clothes and a Japanese towel stylishly dyed with [characters spelling the name of] Yaeko Mizutani [famous Japanese actress] as a *hachimaki* [headband] because my hair is too long. Since coming to the mountains, we've become suntanned. My body's color is brown. Everyone who passes us might think I'm an Indian.

PART 6

Even though the donkeys carry two boxes they take up space on the trail. When we go down the narrow trail with the sound of the bells, people get out of the way. We walked three miles in three hours and at 9:30 A.M. arrived at the back of Yosemite Lodge. We unloaded the donkeys by a pine tree, and I led the donkeys to the Merced River to give them water.

Even though this is the same national park, Yosemite Valley is crowded with automobiles and the road is shiny with oil. There is a yellow line in the middle of the road and the donkeys refused to cross it. We waited for the cars to pass, then we pushed the donkeys across the road. We washed completely from head to toe in the Merced River then returned to the pine tree.

Mr. Howard, wearing blue overalls, approached me smiling and rubbing his bald head (even though he is young). Mr. Howard took us to his tent at Yosemite Lodge. The tents, and occasionally a cabin, stand in between pine and cypress trees according to their numbers. It looks like a poor village. Most people eat at a restaurant or a cafeteria. There is no grass growing around the tents. It has the appearance of camping with a tent as someone advertised, but compared to camping in the mountains it looks like living in a can. I'm glad I didn't come down here last night.

PART 7

I was very hungry, but first Mr. Howard guided us to the post office, where I mailed the various wildflowers I had gathered. Then we crossed the wooden bridge over the Merced River and went to the cafeteria, where we stuffed ourselves. Outside the window I could see through a willow tree to the river where five or six trout were leisurely swimming. After eating I bought several things at the general store. The road was crowded with cars: bumper to bumper like a school of sardines. Six, seven miles away from here we can enjoy camping in nature.

In my wife's letter, from Mr. Howard, she said Nonaka-san and Kiyasu-san would be at Camp Curry, so I went to look for them. Everyone

Eagle Peak Trail, 1930.
Color woodblock print, 15¾ x 11 in.

This little stream, after having been born at the foot of Mount Hoffmann, comes down murmuring and whispering, leaping and jumping, winding through the forest of gigantic trees for forty miles—and down it goes, 1,800 feet over the cliff, forming one of the world-famous natural wonders, the Yosemite Falls. Its roaring and thundering sounds bound and rebound against the mountaintops and make the whole atmosphere vibrate.

I passed looked at my *hachimaki*. I wondered if people thought that it looked strange or that the design was very stylish. At Camp Curry I talked to the clerk, but they weren't there. I had promised to leave Yosemite Valley at 3:00 to return to the mountains. I had some extra time so I walked around and sketched.

At 3:00 I returned to the pine tree. Mr. Ryder also returned and we brought the donkey to Mr. Howard's tent. We had gifts from San Francisco and we packed these carefully. Then, with the sound of bells, we went back to our 8,000-foot home in the mountains.

In Praise of Nature

[A series of five articles published in an unidentified Japanese newspaper, perhaps in Southern California, 1928. The first in the series is lost.]

NO. 2

When you climb the mountains you can find bracken and coltsfoot. In spring and autumn, after the rains, shoots of young grass and a variety of flowers grow out of the dark soil.

To catch trout, one needs only a hook and a few tools. Using pine grubs or, if you can catch them, angleworms, which live among the pebbles near the stream bank, let down your line and you will have a delicious meal for campers. (Donkeys are very fond of fried trout, so, campers, give them a treat sometimes.)

Camp life is to be found everywhere. You gather firewood with your right hand and cup clear stream water with your left. You are awakened by the chorus of chirping birds and nod off into dreamland listening to frogs and insects while gazing at the starlight through the tree branches. This is an easy, comfortable life. Moreover, in this state of California there are large plains, deserts, a mountain chain along miles of coastline, thousands of rivers and rapids, numerous hills of different shapes, cold streams, and high, famous, snowcapped mountains.

I recommend the route in the Sierra from Oakdale via Knights Ferry to see the scenery at Yosemite Junction. Visit Jacksonville where Bret Harte and Mark Twain lived. Then go over the steep incline of Priest Hill and climb Tioga Road from Big Oak Flat. Depending on the elevation, the trees, plants, flowers, birds, animals, the shape of the mountains, the condition and color of the rocks will differ even though they are the same type.

Wind, rain, thunder, snow, morning and evening views, sun rays that burn the hot sand, tranquil moonlight—all at over 10,000 feet above sea level.

Adorning the heights of the Sierra range are the wildflowers. Every three to seven days they bloom in white, red, yellow, and purple, bursting out in a kaleidoscope of beauty and giving us untold lessons and valuable experiences.

*Nestling at the foot of a high, clear-cut
mountain sleeps Tioga Lake in silence,
waiting, with the spotless skies above,
for the curtain of night to fall and to
envelop all in the mysterious quietness
of the oncoming night.*

Sundown at Tioga, Tioga Peak, 1930.
Color woodblock print, 11 x 15¾ in.

The seeds and roots of the wildflowers find a bed of ground in between the rocks. For eight or nine months of the year they patiently lie buried under several feet of snow. In the warm light of July and August they burst out toward the wide sky.

NO. 3

Old Tim Sullivan is a ranger working in Yosemite National Park. He is from Ireland, stands over six feet tall, and is a former boxer who fought the famous John L. Sullivan. When he was twenty years old, Tim came to the High Sierra as a soldier to fight the Indians. Today he is seventy-four and for the past fifty-four years has been trekking the mountains in all directions— White Wolf Meadow today, Harden Flat tomorrow—with his two donkeys named White and Blue. Almost everyone who wanders into the Sierra will most likely come across him, whether it be at Yosemite Valley, Carl Inn, Aspen Valley, White Wolf Meadow, Dark Hole, Yosemite Creek, Porcupine Flat, Tenaya Lake, Death's Grave, Tuolumne Meadows, or Tioga Pass. In that case, treat him politely with the respect due to an elder and he will kindly tell you, based on his long experiences of fifty-four years, not only about the well-known trails but also about safe water, building fires, and protection against bears and other animals.

According to old Tim, Yosemite National Park spreads over three hundred square miles and has more than four hundred lakes. But these are only what he knows. He told me that although he has walked through much roadless terrain over the years, he still could not say that he has covered every part.

One who holds a paint brush for their life's work tends to label people as academics, impressionists, futurists, or expressionists. Some call a work commercial art and others call it fine art without comprehending nature's broad tolerance. We must not waste time by being prejudiced or judgmental. For thousands of years nature, in its silence, has given us innumerable lessons without prejudice to anyone.

NO. 4

Man has to stand by his own decision and strive to attain his goal wholeheartedly.

I regret that I had never met John Muir, who lived in California, nor heard in his own words his praise of nature. Within this state, as well as nationwide, he was regarded as the father of the movement to protect nature. A man of lofty personality and an untiring energy, his life ended at the age of seventy in the burning Arizona desert.

However, I was fortunate to go on a painting tour of the Sierra with Professor Ryder of the fine arts department of U.C., and to exchange thoughts and feelings and to share camp life with him. Mr. W. Ryder is a native of California. He has had a deep association with nature since the age of thirteen and is an artist who has been advocating the protection of nature since his youth.

I recall June 17th of last year, when we were at the intersection of Tioga Pass and Hetch Hetchy Road. On the bank of the south tributary of the Tuolumne along the way to Harden Meadow was a yellow pine grove, which had been cut for about a half a mile. This ugly sight was such a contrast to the adjoining sublime scenery. It looked as if a man's scalp had been peeled off his skull, leaving behind a part in the dark hair. Thus, the oldest forest in the Sierra was about to be obliterated by senseless human cruelty and his axe.

Mr. Ryder told me that John Muir had headed an appeal of the patriots of this country, which led to President Roosevelt's California visit. Guided by Mr. Tim Sullivan, he personally investigated the site and put an end to the greedy fangs of the politicians. Prof. Ryder is well respected by young artists, more than any other professor in the U.C. art department; it is my utmost pleasure to have him as a friend and colleague. I feel as if John Muir were reborn in him.

NO. 5

There is an old saying, "Writing is a person." Art is also a personality. If you were able to face all different phenomena with the clear, bright eyes of the mind, you are automatically nurtured in the bosom of nature's spirit. Even if a man stands only five feet tall and cannot leave the ground, there is unlimited soaring on the wings of creation.

I was filled with youthful dreams and spirit when I left Yokohama Port. I faced my father, whose face had an indescribable expression, which I had never seen before. "Father, now I am going. I will return when I am able to create, without fail, masterpieces that will be known to the world as those of Chiura Obata." My father, to whom I had thus bid farewell, died this March, the day after my exhibition was closed, following a successful showing at the San Francisco East West Art Association.

> Snowy mountain road,
> Pine needles scattered by the storm.
> California to the west, Nevada to the east.
> Even the wind freezes on Tioga Pass.

After following an untrodden path for several miles over the snow in the High Sierra, I discovered the five-needle pine lying dead in the snow, part of its trunk protruding. On the dead trunk were a few green branches, bravely struggling to live.

Struggle, Trail to Johnson Peak, 1930.
Color woodblock print, 11 x 15¾ in.

To the right of the 10,000-foot summit of Tioga Pass stands Mount Dana at 12,500 feet. On the left towers Tioga Peak like a gigantic screen. The old pine on the Tioga plain has borne avalanches, fought wind, rain, ice, and snow, and has suffered bitter times for several hundred years. Like a warrior at the end of his life, he embraces with his rough roots the young trees growing up and surrounding the fallen parent. When I see this I feel that man should be devoted and struggle hard to follow his own ambition without willful, selfish reasons.

I feel that to weep and to be caught in trivial emotions is impure, and I would be ashamed before nature. Now, I have come to Southern California to exhibit my work of the past twenty years to brothers and sisters and young people who are also working hard with similar thoughts in spite of different vocations.

I dedicate my paintings, first, to the grand nature of California, which, over the long years, in sad as well as in delightful times, has always given me great lessons, comfort, and nourishment. Second, to the people who share the same thoughts, as though drawing water from one river under one tree.

My paintings, created by the humble brush of a mediocre man, are nothing but expressions of my wholehearted praise and gratitude.

Obata Gets Spirit of California

"Obata Gets Spirit of California in His Prints: Sierra Trip with Obata Is Told by John [sic] Howard, Important Local Artist" [*Art and Artists* 2 (January 1931): 1, 3]

During the summer of 1927 I received word from my friend Worth Ryder, "Don't fail to join us. We can pack you out from Yosemite." Obata is a perfect camping companion.

So on the day set we met and started off up the trail behind two sturdy donkeys. Worth leading the way, Chiura next with his picturesque Japanese head gear and rucksack bulging with brushes, paint and rice paper, myself urging on the donkeys, bringing up the rear.

Every pause for rest saw Chiura at work. That is almost the first impression he gives one, either working or on his way to work; never getting ready. Just somehow always ready, for at least a brief sketch.

Camping that night beyond the head of Yosemite Falls, we sat before the friendly campfire in the cool silence of the high Sierra, and Chiura told us he must paint one hundred pictures during this month of mountain wanderings. The first one would be of Yosemite Falls, for they had spoken to him in music that afternoon on the way up out of the Valley.

Next morning he disappeared down the trail we had come, and as the sun rose high, groups of hikers began passing, telling of an artist working like mad at the foot of the first falls. As the morning wore on, more hikers passed, each with a word of wonder, till finally along came the artist himself, all fresh and smiling, with a superb painting under his arm.

That was a typical morning for Obata. A long hike, hours of work in the sun, the stiff hike back to camp with another fine painting, and ready to repeat it in the afternoon.

But later during the trip, there would be times when he would reach a temporary limit of producing paintings. Then he would dig out from his bag a bit of red stone or a piece of white quartz found near some deserted mine, gather a bit of moss, a willow twig or a tiny fern and plant a Japanese garden

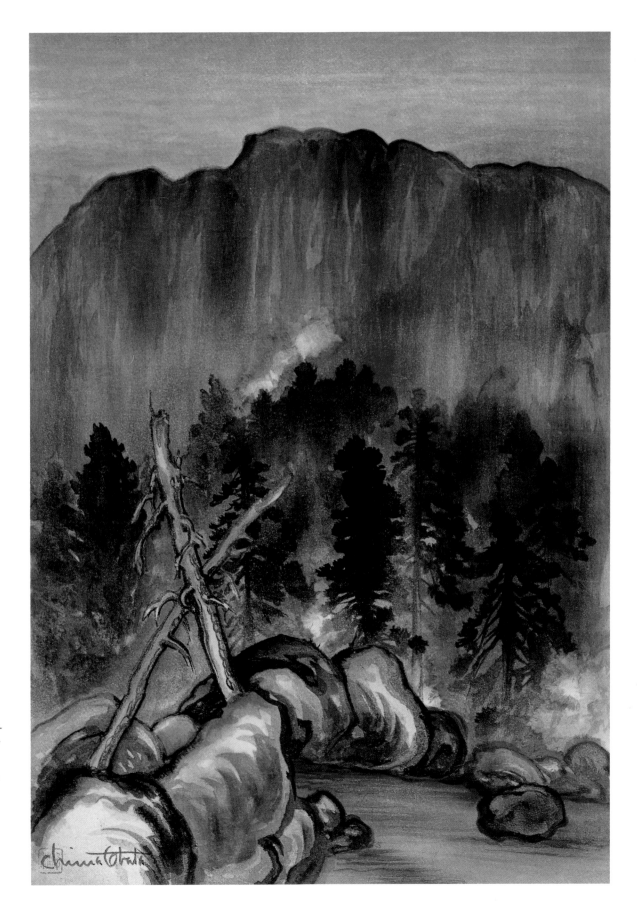

Merced River, Yosemite Valley, 1930.
Color woodblock print, 15¾ x 11 in.

*Clad in a misty autumnal vapor, the
high cliff at the entrance of Yosemite
Valley looks sleepily down at the
murmuring river that flows below,
singing a cradle song.*

Untitled (Artist Sketching), 1927.
Sumi and watercolor on paper,
15¾ x 11 in.

the size of one's palm. Or there were fish to catch. That was a sport near to his heart. And once a week we would have dinner prepared by his hand—chop sticks. Skiaki [sukiyaki] and rice, tasty fresh trout, strange dried fish from Japan, bean cakes, and hot saki [sake] would mysteriously appear—the perfect beverage for the mountains, with the smell of pine in one's nostrils.

Afterwards, before turning in for sleep, Obata would bring forth his philosophies of life, how to remain young, how to appreciate every minute of existence and time, how right it was to be happy and cheerful and productive, how wrong to shed tears, do nothing and waste time and strength. That to be an artist was best of all things.

No idle talk was this for him. Obata lives his beliefs and more. He influences those who know him to live deeply and well.

He stands for work, love and laughter; indefatigable work; a sensitive love of life, of mountains, of tiny plants and mighty trees, of fog and skies; and of laughter that comes from the heart, the joy of living and the knowing that all is right with the world because he has made it his.

Chronology

1885	Born 18 November in Okayama-ken, Japan, and raised in Sendai.
1899	Studied in Tokyo with Tanryo Murata, Kogyo Terasaki, and Gahō Hashimoto.
1900	Joined the Kensei-Kai, a group of young artists who advocated a modern form of Japanese painting.
1903	Moved to San Francisco.
1906	Made on-site sketches of the San Francisco earthquake and worked as an illustrator for the city's Japanese newspapers, *The New World* and *The Japanese American*.
1912	Married Haruko Kohashi.
1915–27	Worked as an illustrator for *Japan* magazine.
1920	Spent much of the decade painting landscapes throughout California.
1921	Helped establish the East West Art Society in San Francisco.
1927	Spent most of the summer on a sketching tour of Yosemite and its high country with Worth Ryder and Robert Howard. Produced over 100 new paintings.
1928	Returned to Japan, following his father's death. Supervised the production of 35 color woodblock prints of California landscapes (most of them Yosemite subjects) for his *World Landscape Series*. They were exhibited at the "Eighty-seventh Annual Exhibition" at Ueno Park, Tokyo; *Lake Basin in the High Sierra* won first prize.
1930	One-person exhibitions, primarily of the *World Landscape Series*: California Palace of the Legion of Honor and California School of Fine Arts, both San Francisco; Honolulu Academy of Arts; and Haviland Hall, University of California, Berkeley.

Chiura Obata, shortly after arriving in San Francisco, circa 1903.

| 1932 | Appointed instructor in the Art Department at the University of California, Berkeley. One-person exhibitions: M. H. de Young Memorial Museum and Courvoisier Gallery, both San Francisco; Stanford University Art Gallery. A four-screen panel of horses was exhibited at the de Young Museum, and four paintings were shown at the "Western Watercolor Annual," California Palace of the Legion of Honor. |

Berkeley, 1930s.

| 1936 | One-person exhibitions: Artists' Cooperative Gallery, San Francisco; Best's Studio, Yosemite Valley. Group exhibition: "International Watercolor and Travelling Show," The Art Institute of Chicago. |

| 1937 | May–June: taught outdoor sketching classes in Yosemite Valley. One-person exhibition: University of North Carolina, Chapel Hill. |

| 1938 | One-person exhibitions: E. B. Crocker Art Gallery, Sacramento (and demonstration); Best's Studio, Yosemite Valley. Lecture and demonstration: Ahwahnee Hotel, Yosemite Valley. |

| 1939 | One-person exhibition of 40 paintings on silk, Yosemite Valley. Lectures and demonstrations: Ahwahnee Hotel and the Ranger's Club, Yosemite. |

| 1940 | One-person exhibition: Powerhouse, University of California, Berkeley. Group exhibition: "Twentieth Annual California Watercolor Society Show," Los Angeles County Museum. |

| 1941 | One-person exhibition: University of Redlands, Redlands, Calif. Group exhibitions: "Contemporary Art Show of Japan," de Young Museum; "Twentieth International Exhibition of Watercolor," The Art Institute of Chicago. Lectures and demonstrations: Wawona Hotel, Yosemite. |

| 1942 | April: imprisoned at the Tanforan detention center. During stay there, organized an art school with over 650 camp residents as students. September: was moved to Topaz Relocation Center, Topaz, Utah. Appointed director of the Topaz Art School. |

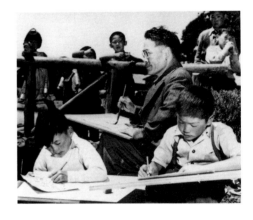

Obata teaching a children's art class during internment at the Tanforan detention center, San Bruno, California, August 1942.

1943 Released from Topaz Relocation Center and moved with family to St. Louis, finding employment with a commercial art company.

1945 When military exclusion ban lifted, reinstated as instructor in the Art Department, University of California, Berkeley.

1946 One-person exhibitions: College of the Pacific, Stockton, Calif.; University of Southern California, Los Angeles.

1947 Group exhibition: "Eleventh Annual Drawing and Print Exhibition," San Francisco Museum of Art. Summer: sketching and painting trip with the Sierra Club.

1948 Promoted to Associate Professor of Art. One-person exhibition: Maxwell Art Gallery, San Francisco. Group exhibition: Fine Arts Gallery, San Diego. Summer: sketching and camping trips to Yosemite and the High Sierra.

1949 Taught summer session at the University of New Mexico, Albuquerque. One-person exhibitions: Jean Williams Art Gallery, Albuquerque; Santa Fe Art Museum.

1950 One-person exhibition: Doll and Richards, Boston. Group exhibition: "Eleventh Annual Exhibition of the Society of Western Artists," de Young Museum.

1951 One-person exhibition: Museum of Art, Santa Barbara. Group exhibition: "Twelfth Annual Exhibition of the Society of Western Artists," de Young Museum. Summer: sketching and painting trip with the Sierra Club.

1952–53	Camping and sketching trips to Yosemite.
1953	Exhibition: Graves Gallery, San Francisco.
1954	Became naturalized citizen. Retired as Professor Emeritus from the University of California. Organized Obata Tours to Japan, which introduced many Americans to Japanese aesthetics, through 1969.
1955–70	Gave lectures and demonstrations on Japanese brush painting throughout California. Venues included Bakersfield Art Association; Carmel Women's Club; San Bernardino Valley College; San Diego Museum of Art; Diablo Japanese American Club, Concord; and Cherry Blossom Festival, San Francisco.
1961	One-person exhibition: Fine Arts Gallery, San Diego.
1965	Received Order of the Sacred Treasure, 5th Class, Emperor's Award for promoting goodwill and cultural understanding between the United States and Japan.
1975	Died, aged 90.
1976	Group exhibition: "A View from the Inside," The Oakland Museum.
1977	Retrospective: "Chiura Obata: A California Journey," The Oakland Museum.
1981	Group exhibition: "Detention Center: A Day of Remembrance," San Francisco State University.
1987	Group exhibition: "A More Perfect Union: Japanese Americans and the Constitution," Smithsonian Institution, National Museum of American History.
1992	Group exhibition: "The View from Within: Japanese American Art from the Internment Camps, 1942–1945," Wight Art Gallery, University of California, Los Angeles.

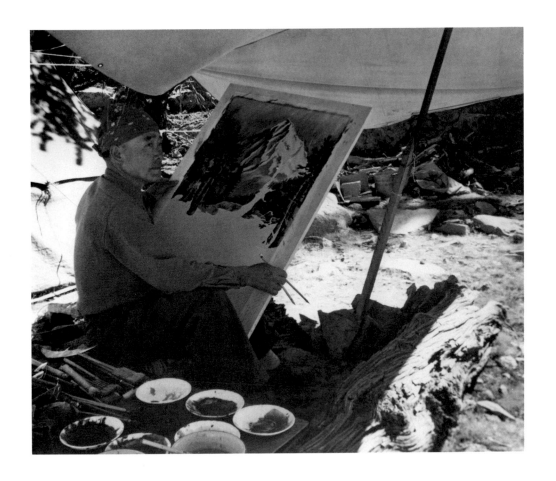

Obata painting *Evening Glow* in Vidette Meadow, King's Canyon National Park, August 1948, at Sierra Club base camp. Photograph by Cedric Wright. Courtesy of Susan Herzig & Paul Hertzmann, Paul M. Hertzmann, Inc., San Francisco.

147

Selected Bibliography

Albright, Thomas. "A Fascinating Survey of Obata's Early Art." *San Francisco Chronicle*, 18 June 1977.

Annex Gallery. *Fifty Years of California Prints, 1900–1950*. Exh. brochure. Santa Rosa, Calif.: Annex Gallery, 1984.

Argonaut (San Francisco). 1928 and 1932.

Blakeney, Ben Bruce. *Yoshida Hiroshi: Print-Maker*. Tokyo: The Foreign Affairs Association of Japan, 1953.

"Chiura Obata." In *California Art Research*, 1st series, 120–60. San Francisco: WPA Federal Art Project, 1937.

Cross, Miriam Dungan. "Discover Nature in Obata Art." *Oakland Tribune*, 26 November 1967.

Demars, Stanford E. *The Tourist in Yosemite, 1855–1985*. Salt Lake City: University of Utah Press, 1991.

Dungan, H. L. "Artist Paints Picture of Beautiful Princess Between 2 and 3 A.M." *Oakland Tribune*, 24 March 1935.

East West Gallery of Fine Arts. *Chiura Obato [sic]*. San Francisco: East West Gallery of Fine Arts, 1928.

Gesensway, Deborah, and Mindy Roseman. *Beyond Words: Images from America's Concentration Camps*. Ithaca, N.Y.: Cornell University Press, 1987.

Hailey, Gene. "Critic in Praise of San Francisco Man." *Japanese American News*, 1 March 1928.

———. "The Permanence of Japanese Pigments." *Argus* 3 (May 1928): 11.

Hailey, Gene, ed. *California Art Research*. Vol. 20, no. 2. San Francisco: Works Progress Administration, 1937.

Haley, Monica. "Worth Ryder: Artist and Art Educator." Bancroft Library, University of California, Berkeley.

Haswell, Harry. Review. *Wasp-News Letter*, 18 April 1939.

Higa, Karin, et al. *The View from Within: Japanese American Art from the Internment Camps, 1942–1945*. Exh. cat. Los Angeles: Japanese American National Museum, 1992.

Howard, Robert. "Obata Gets Spirit of California in His Prints." *Art and Artists* 2 (January 1931): 1, 3.

Hubbard, Grace. Review. *Wasp-News Letter*, 10 March 1928.

———. Review. *Wasp-News Letter*, 21 May 1932.

Hughes, Edan Milton. *Artists in California, 1786–1940*. 2d ed. San Francisco: Hughes Publishing Co., 1989.

Jenkins, Donald. *Images of a Changing World: Japanese Prints of the Twentieth Century*. Exh. cat. Portland, Oreg.: Portland Art Museum, 1983.

Kistler, Aline. Review. *San Francisco Chronicle*, 11 March 1928.

Kurihara, Marie. "'Plain, Simple and Definite': Sumi-e Paintings of Professor Obata Portray His Philosophy of Life." *Pacific Citizen*, 18–25 December 1964.

Merritt, Helen. *Modern Japanese Woodblock Prints: The Early Years*. Honolulu: University of Hawaii Press, 1990.

Merritt, Helen, and Nanako Yamada. *Guide to Modern Japanese Woodblock Prints, 1900–1975*. Honolulu: University of Hawaii Press, 1992.

Morris, Eleanor. Review. *Daily Californian* (Berkeley), 20 March 1928.

Nahl, Perham. "Chiura Obata." *Art and Artists* 2 (January 1931): 1–2.

Oakland Tribune. 1927–28 and 1930–32.

Obata, Chiura. "How Painting Is Taught in Japan." *Argus* 3 (April 1928): 7.

———. *Sumi-e*. Berkeley: author, 1967.

Ogura, Tadeo, et al. *The Complete Woodblock Prints of Yoshida Hiroshi*. Abe
 Publishing Co.

Pachter, Irwin J., and Takushi Kaneko. *Kawase Hasui and His Contemporaries: The
 Shin Hanga (New Print) Movement in Landscape Art*. Exh. cat. Syracuse, N.Y.:
 Everson Museum of Art, 1986.

Rauch, Rudolph S. "Internment." *Constitution* 4 (Winter 1992): 30–42.

Robertson, David. *West of Eden: A History of the Art and Literature of Yosemite*.
 Yosemite National Park, Calif.: Yosemite Natural History Association;
 Berkeley: Wilderness Press, 1984.

Russell, Carl P. "Opening New Yosemite Wonders." *Yosemite Nature Notes* 4
 (April 1925): 25–26.

Salinger, Jehanne-Bietry. Review. *San Francisco Examiner*, 11 March 1928.

San Francisco Chronicle. 1927–28 and 1930–32.

San Francisco Examiner. 1927–28 and 1930–32.

San Francisco Museum of Art. *East West Art Society Second Exhibition*. San Francisco,
 1922.

Sibley, Robert, ed. *The Seasons at California*. Berkeley: California Monthly, 1939.

Sommer, Anna. "Two Exhibitions Here Will Show Subtle Influence of Japanese on
 Creative Art." *San Francisco News*, 14 May 1932.

Soong, James H. *Chiura Obata: A California Journey*. Exh. brochure. Oakland, Calif.:
 The Oakland Museum, 1977.

Colophon:
Untitled, 1927.
Pencil on paper, 6 x 9 in.

OBATA'S YOSEMITE
was designed by Desne Border, San Francisco.
The text was set in Sabon, designed by Jan Tschichold;
photocomposition by Peter W. Stoelzl, Mackenzie-Harris Corporation.
The book was printed and bound by Nissha Printing Co., Ltd., Kyoto, Japan.
Publication was coordinated by Steven P. Medley, Yosemite Association.